IMAGES
*of America*

# EARLY
# PLACENTIA

This book is dedicated to two local residents who became "accidental historians" and whose work did much to make this book possible. George Gilman Key (left) was born in Placentia in 1896 and spent most of his 80 years here. He followed his father as a citrus rancher and was active in several local organizations. But his greatest service to the community was to preserve his 1898 ranch and collect agricultural equipment there as other ranches closed. He supplemented this with hundreds of photographs and his own written recollections. In 1980, Orange County bought his ranch and made it a historic park and published his recollections and some photographs as *Early Placentia*. Virginia Lewis Carpenter (right), born in 1904, came to Southern California as an infant and lived in various places here. Though not trained as such, in 1953, she was hired as a librarian by Placentia. Responding to children's need for local history, she collected documents and pictures and became well-known in both city and county historical circles. After retiring in 1972, she wrote *A Child's History of Placentia*, followed by the larger *Placentia: A Pleasant Place* and an account of the founding Ontiveros family. Before her death in 1995, she gave her extensive collection of documents and photographs to the Placentia Library. These books and collections remain basic sources for early Placentia history.

ON THE COVER: This image of the first packinghouse established by a Placentia orange growers association illustrates Valencia orange growing at the crossroads between being largely a type of agriculture pursued by a few ranchers and becoming an industry replete with a labor force and marketing organizations that would dominate the economy of Placentia and adjacent areas. (Courtesy of First American Title Company.)

IMAGES
*of America*

# EARLY
# PLACENTIA

Jeanette Gardner, Lawrence de Graaf,
Placentia Historical Committee

ARCADIA
PUBLISHING

Published by Arcadia Publishing
Charleston SC, Chicago IL, Portsmouth NH, San Francisco CA

Printed in the United States of America

Library of Congress Catalog Card Number: 2006938518

For all general information contact Arcadia Publishing at:
Telephone 843-853-2070
Fax 843-853-0044
E-mail sales@arcadiapublishing.com
For customer service and orders:
Toll-Free 1-888-313-2665

Visit us on the Internet at www.arcadiapublishing.com

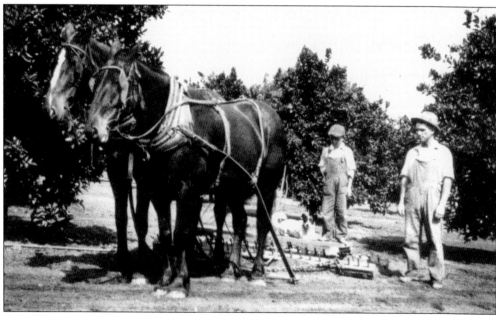

Early Placentia was an entirely rural area until 1910, and farming was both a livelihood and a way of life. These men are guiding mules and a cultivator used to dig ridges around trees to hold irrigation water. Such scenes were typical on Placentia ranches by 1900, as citrus growing became the mainstay of the area's economy. (Courtesy of Anaheim Public Library.)

# CONTENTS

# ACKNOWLEDGMENTS

This book was the collective project of the Placentia Historical Committee, a group of citizens that has advised the city on historical matters and promoted interest in local history since 1986. The authors gratefully recognize the assistance of all members of this committee in selecting pictures, finding historical information on them, and helping organize this work. In addition to the two authors, these members are: Eddie Castro, Kathy Frazee, Jan Henderson, Wendy Elliott-Scheinberg, John Walcek, and Bill Zavala. We are also grateful to liaison Leigh De Santis for her work on the contractual arrangements.

The illustrations in this book come from a variety of repositories, and the staff at each of these was always cooperative and helpful. The largest number of pictures came from the Placentia Public Library Placentia History Room, where the Virginia Carpenter collection is stored. Three people have volunteered countless hours to organize and arrange this and other local collections: Marie Schmidt, Pat Irot, and Pat Jertberg. We, along with others who have used this history room, owe a great debt to their work. Another important source was the collection stored at Key Ranch. We appreciate the services of ranger Sam Edwards in making this facility available. Photographs have also been obtained from Anaheim and Fullerton Public Libraries, where Jane Newell and Cathy Thomas, respectively, assisted us in finding pictures. Kathy Frazee at the Center for Oral and Public History, California State University, Fullerton, provided photographs from its Placentia packinghouse-workers exhibit. Longtime Placentia residents Alfred Aguirre and Mary Castner provided personal pictures. The final work on photographs was done at the Placentia History Room, and the authors are grateful for the assistance of Gary Bell and Vernon Napier. Finally, we are grateful for the artistic talents of Dalton Thomas on the line drawings in this book. Books often reach the point where the authors become as wedded to the project as to any person. For their patience in enduring many hours of loneliness, we give our profound thanks to our respective spouses, Mike and Shirley.

# INTRODUCTION

The history of a community may appear, like history itself, to be a seamless web. But many cities have a point of time at which their basic features change and their pattern of development takes a new course. Such was the case of Placentia, California, which by 2006 was a city of 50,000 in north Orange County. Until the middle of the 20th century, it was a modest-size town surrounded by miles of farmland punctuated by oil derricks and a few blocks of residences. Since 1960, the agriculture, most oil facilities, and many ranch houses have disappeared. But photographs have preserved much of the distinctiveness of the decades when Placentia was largely ranchos, oranges, and oil, and this book will provide an opportunity to revisit that era.

While Native Americans frequented the Placentia area for centuries before Europeans arrived, the recorded history of that city begins, like many others in Southern California, with Spanish explorers and Mexican land grants. Rancho San Juan Cajón de Santa Ana, granted to Juan Patricio Ontiveros and settled by his son in 1837, began the development of permanent settlements and agriculture in Placentia. Most of the other pioneer settlers were Anglo Americans, including Daniel Kraemer and his sons, William McFadden, and J. K. Tuffree. But the title of ranchero (usually translated to rancher) continued to designate those who acquired portions of the original land grant and supplemented grazing cattle with growing various crops. The founding of an irrigation district and school district by the mid-1870s created a sense of community among the dispersed ranches. The area assumed a nominal identity in 1879, when Sarah Jane McFadden suggested renaming the school district Placentia, meaning "a pleasant place."

A more distinct economy began in 1880, when Richard Gilman established the first commercial Valencia orange grove at the western edge of the area. Older settlers soon adopted the crop, and these ranchers, along with later ones, such as A. S. Bradford, became leaders in the development of Placentia. Much of the work on these farms was done by a population of laborers. They dug the irrigation canals that were vital to citrus growing and harvested the crops. Initially mostly Mexican and white, this population included Chinese and Japanese by the late 19th century.

In 1910, the scattered ranches that composed Placentia were supplemented by a town. The Santa Fe Railroad built tracks into the area and erected a depot on land donated by Samuel Kraemer. Richard Melrose and A. S. Bradford then laid out lands they owned near the tracks into several blocks of what quickly became residential and commercial buildings. "The Town that Grows," as Placentia called itself, did not expand too much beyond this fraction of a square mile in the next 50 years. But it became a major center for processing oranges as local growers' associations built packinghouses along the railroad tracks.

The economy soon shared another development that had come to Southern California: oil. In March 1919, an oil well on land owned by Charles C. Chapman exploded into a gusher that lasted for several days. Other fields soon developed, and derricks were sprinkled over what is today eastern and northern Placentia by the mid-1920s. The town of Richfield (later Atwood) was built to house oil workers. Meanwhile, citrus groves continued to expand, covering much of the future city by the end of the decade. Mexicans made up much of the labor force and built

the community of La Jolla to the south of the town. Placentia also augmented its school system, erecting several elementary schools from about 1910 to about 1930 and a high school in the 1930s. Most schools came to be designated for either white or Mexican students, ostensibly due to differences in language and learning ability.

Placentia would change little over the next several decades, despite national and global events that caused great change in other parts of Southern California. The Great Depression led to a short-lived strike of Mexican citrus workers in Placentia and other *colonias* in the county. World War II saw many of the town's men enter the service and created housing shortages for some at home. One notable outgrowth of the war was the formation of a campaign to end segregated schools by Mexican American veterans, a move that achieved a quiet end to the policy in 1948. But a traveler who had gone through the town in the 1920s might have returned in the 1950s to find that little had changed in most of the area.

In some adjacent cities, however, dramatic transformations were occurring. Anaheim grew from barely 10,000 people in 1950 to over 100,000 ten years later, as its orange groves gave way to houses, freeways, industry, and Disneyland. Fullerton also experienced substantial growth, capped by the creation of a state college campus on its border with Placentia in 1959. By then it was becoming obvious that the days when Placentia could be described primarily as ranchos, oranges, and oil were coming to an end.

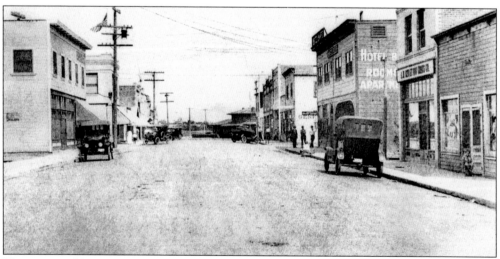

This image of Santa Fe Avenue c. 1920 shows a different part of Placentia after 1910: a small town, including this business district. Its stores filled many of the needs for which residents had previously journeyed to other towns. The automobiles and the absence of horses illustrate the rapid change in transportation. (Courtesy of Placentia Public Library.)

# *One*

# NATIVE AMERICANS AND EUROPEAN PIONEERS

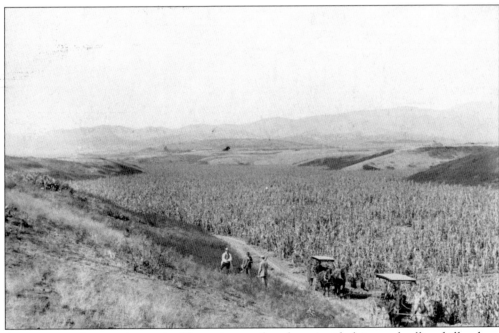

American settlers coming to the Placentia area found semi-arid plains and rolling hills where vegetation consisted largely of grass and bushes. In the 1890s, when this picture was taken of a portion of the Kraemer Ranch in Placentia, much of the land was undeveloped, and agriculture was as much grains as fruit. Only horse-drawn vehicles and human footsteps traversed the narrow paths of dirt that served as roads. By 1910, Placentia still had many open spaces, but the seeds for drastic changes in this scenery were being sown. (Courtesy of Anaheim Public Library.)

While American settlers found the Native Americans of the Los Angeles Basin "primitive" in their scanty dress, limited technology, and habits, some aspects of their culture were quite sophisticated. One was their belief in Chinichinich, a spiritual figure who represented both God and a moral leader. This religion was accompanied by elaborate rituals, which included dress like the one in this drawing from Alfred Robinson's *Life in California* (1846). (Courtesy of Dalton Thomas.)

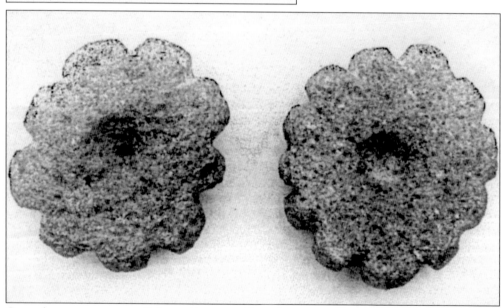

Cogged stones were one of the earliest tangible indications of human settlement in Orange County. They were unique to Native Americans who inhabited the Santa Ana River Basin over 2,500 years ago. They were probably used for rituals or religion. They vary is size and workmanship and seem to have been abandoned by later Native American cultures. (Courtesy of Orange County Centennial.)

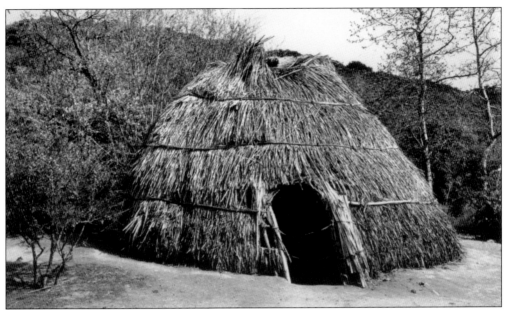

Native Americans through most of the Los Angeles Basin were of the Gabrielino cultural group, which lived in small villages of reed-thatched huts like this reproduction. These dwellings, up to 30 feet in diameter, were sometimes moved in seasonal migration. As many as 1,000 Native Americans may have lived in northern Orange County, subsisting on wild plants and animals. (Courtesy of American Title and Trust.)

Bernardo Yorba was the son of a soldier in the Portola expedition of 1769, which was the first European presence in Placentia. Building on a Spanish grant to his father, in 1834, he received title to Rancho Cañon de Santa Ana east of Placentia. He established the Upper Santa Ana School, the first in the area, and dug some of the earliest irrigation ditches. (Courtesy of Placentia Public Library.)

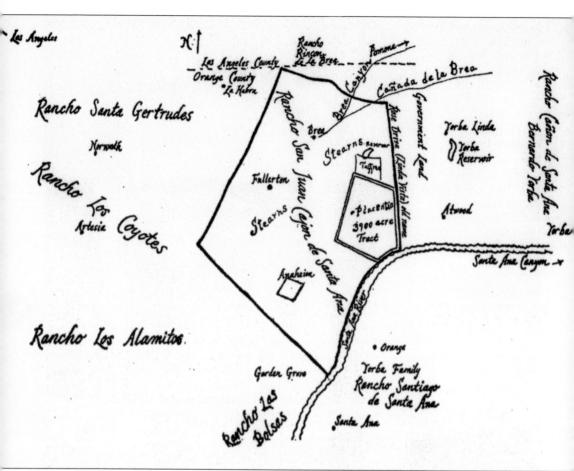

This map shows the land grants in north Orange County and their relation to modern cities. The 3,900-acre square in the Ontiveros rancho, which includes Placentia, was deeded by Juan Pacifico to his sons. The rest of his rancho was sold in 1863 to the Stearns Rancho Company, which gradually sold parts of it to early settlers. The 3,900 acres remained in the Ontiveros family until 1864, when the Ontiveros sons sold it to their brother-in-law, Augustus Langenberger. In 1865, he sold this tract to Daniel Kraemer. (Courtesy of Friis-Pioneer Press.)

Juan Pacifico and Martina Ontiveros were the first non–Native American settlers in Placentia. The son and grandson of Spanish soldiers, Juan Pacifico was deeded Rancho San Juan Cajón de Santa Ana, where he built an adobe house and raised cattle, in 1837. In 1856, he sold a small part to the Anaheim colony and moved to Santa Maria. His sons took over most of the rancho, and several daughters married prominent local men, leaving a family heritage that continues to the present. (Courtesy of Placentia Public Library.)

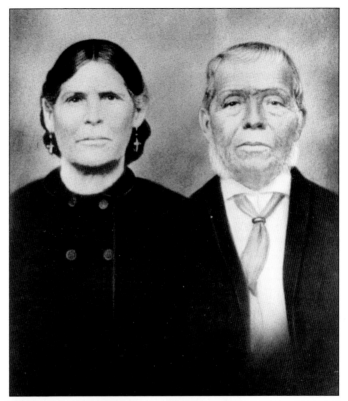

This adobe was built by Juan Pacifico Ontiveros in or shortly after 1837 and was home to his family and his sons until 1864. All known pictures are after 1942, when the adobe was modified. Like most adobes, it had a dirt floor, walls at least 18 inches thick, and narrow windows. Daniel Kraemer bought this part of the rancho, and his family continued to live in it into the 1960s. It was demolished in 1979, and only a historical plaque marks its site. (Courtesy of Placentia Public Library.)

Daniel Kraemer was the first non-Hispanic resident of Placentia. He immigrated from Germany in 1842 and came to California in 1865. He bought the 3,900-acre plot the Ontiveros sons had sold to a relative and moved his family onto it in 1867. They raised grain, grapes, walnuts, and sheep. Daniel died in 1882, but his family remained prominent landowners and citizens of Placentia through the 20th century. (Courtesy of Placentia Public Library.)

William McFadden was another of the earliest settlers, buying land in Placentia in 1869. He grew barley and became the area's first teacher, working at the Upper Santa Ana School. He later served 10 years as superintendent of schools for Los Angeles County (which then included Orange County). McFadden is pictured below (left end, middle row) with his children and grandchildren; his wife, Sarah Jane, is on the right end of the same row. (Courtesy of Placentia Public Library.)

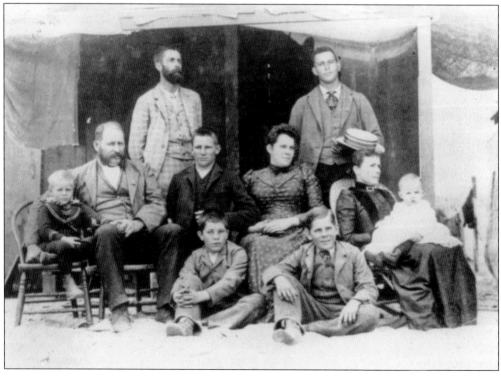

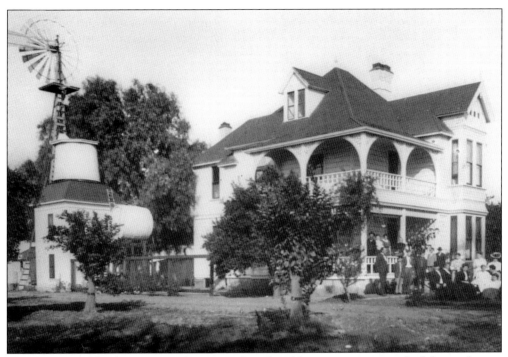

The first McFadden house was a four-room, board-and-bat structure, typical of those of many early settlers. Also typical was this much larger replacement ranch house, built in 1888. Its pump house and windmill were also common and attest to the need to drill individual wells to obtain water for household and often agricultural needs. (Courtesy of Key Ranch.)

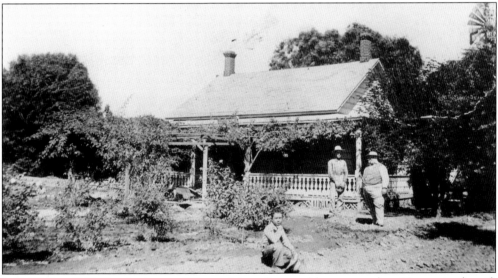

J. K. "Colonel" Tuffree had one of Placentia's earliest and largest ranches. He received a gift of 640 acres from his father-in-law, who was a trustee for Stearns Rancho. The east end of this ranch would become Tuffree Reservoir, a major source of irrigation water. This house, built in 1873, is shown here with the colonel on the right. This 1890s photograph illustrates the minimal landscaping of many early ranches. Tuffree's family subsequently built several large houses in Placentia, two of which still stand. (Courtesy of Key Ranch.)

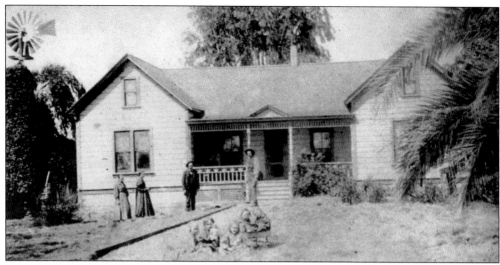

This house was part of the Southern California Semi-Tropical Fruit Company ranch, started when Richard Gilman bought 110 acres in western Placentia in 1872. In 1880, he planted the first commercial Valencia orange grove, which soon became the leading fruit crop in Placentia. The tall man on the right of this 1896 photograph is George B. Key, a Canadian who worked for Gilman and would set up Key Ranch in 1898. (Courtesy of Key Ranch.)

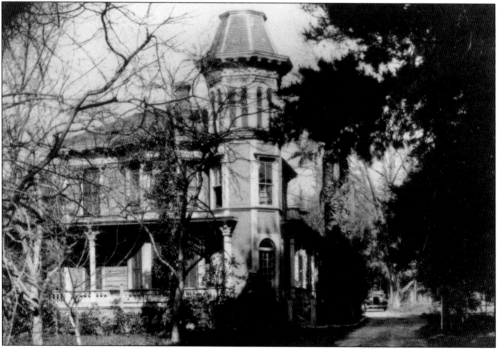

Unique among Placentia's early settlers was the Societas Fraternas, which was formed in 1876 by George Hinde. He built this ornate house along Placentia Avenue and soon attracted a colony, including Dr. Louis Schlesinger, who brought the idea of eating only raw fruits and vegetables—hence their name: "Grasseaters." This reclusive group was also controversial for its belief in spirits, but it continued into the 20th century. This house was demolished in the 1970s. (Courtesy of John Walcek.)

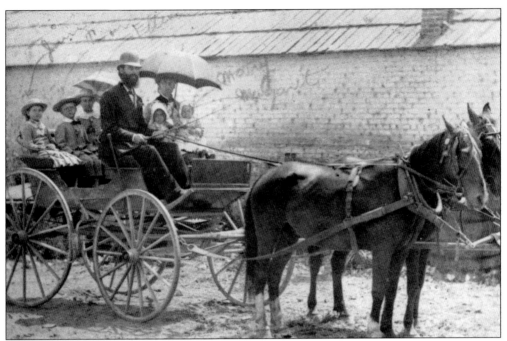

One person the society attracted to Placentia was Thomas Strain, an Irish vegetarian. He set up a ranch near the colony in 1882. He later established a packinghouse and was a promoter of cooperative marketing. This 1880s picture of Tom, his wife, Jane, and their five children illustrates the most common mode of family transportation at this time, the horse and buggy, with umbrellas providing shade. (Courtesy of Placentia Public Library.)

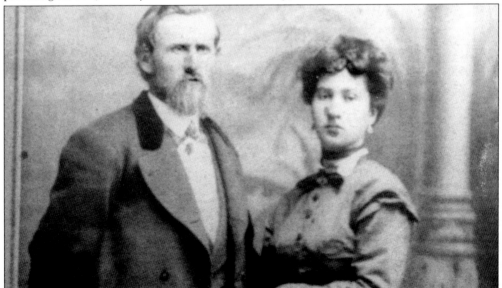

Charles and John Wagner came from Germany and initially settled in the hills to the north of Placentia in 1871. They were among the few successful sheep ranchers in the area, but they also grew various fruit trees and grapes, some of which were destroyed by periodic diseases. This photograph of Charles and his wife, Josephine, was taken shortly before his death in 1880. (Courtesy of Placentia Public Library.)

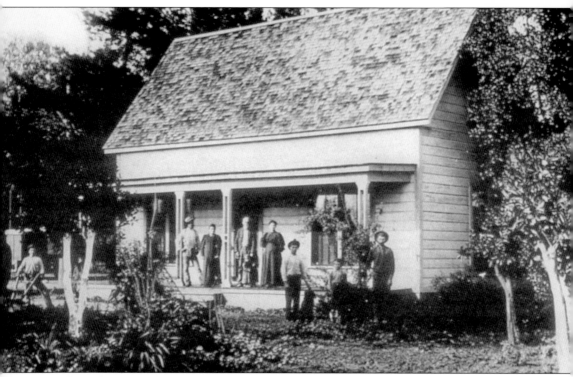

By the early 1880s, the Wagner family moved to Placentia, where this house was built along present-day Yorba Linda Boulevard. This photograph shows John Wagner Sr. and his wife, Josephine (center), with some of Charles Wagner's children and friends. Charles Wagner's three sons later divided the family ranch, and each built large houses that still stand today along or near the boulevard. (Courtesy of Placentia Public Library.)

# Two

# A COMMUNITY OF
# FARMERS

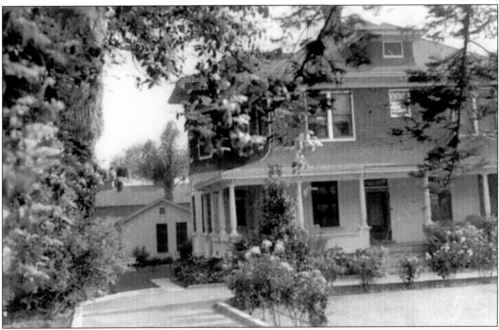

Albert Bradford demonstrated the wealth he accumulated within a decade of coming to Placentia by building this mansion for his Tesoro (Treasure) Ranch in 1902. Its clapboard first story reflected the exteriors of many contemporary ranch houses, while its top story used shingles. It had a wraparound porch, extensive yard, and later a new addition to ranch houses: a lawn. This early picture shows the whole house in its original construction along with its barn. In the 1970s, this house partly burned. The Bradford family gave it to the city, which leased it to the Placentia Founders Society. That organization oversaw its restoration and managed it as a historic house. It was put on the National Register of Historic Places and is a Placentia City Landmark. Bradford was one of the most successful ranchers in Placentia, but he was only one of quite a few who upgraded their early houses as they developed much of Placentia's open spaces into prosperous farms between the early 1900s and the 1920s. (Courtesy of Placentia Public Library.)

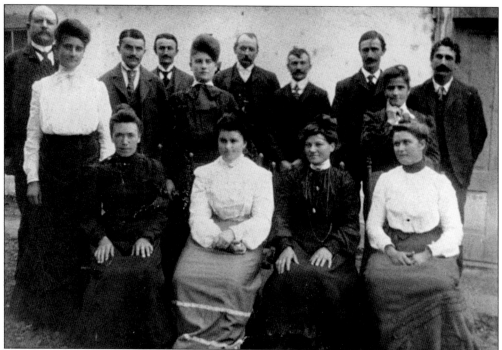

This portrait of the Allec family is an example of the large families of siblings and spouses that immigrated (in this case from France) to the Placentia area. John and Peter Allec raised sheep and cattle before working on a Kraemer ranch and setting up their own citrus farm. They are posing in front of the Ontiveros adobe in the early 1900s. (Courtesy of Key Ranch.)

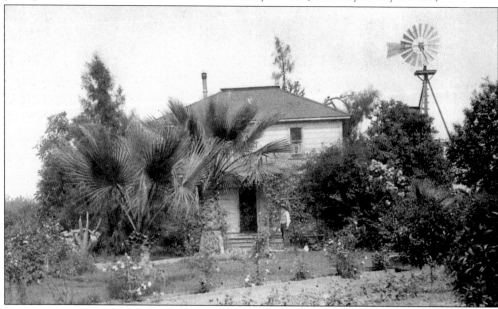

The house of Theodore Staley has most elements of early ranch houses: young citrus trees, vegetables, flowers, and the ubiquitous windmill that supplemented irrigation ditches as the water source. Staley and his family were active in Placentia church and social organizations. (Courtesy of Placentia Public Library.)

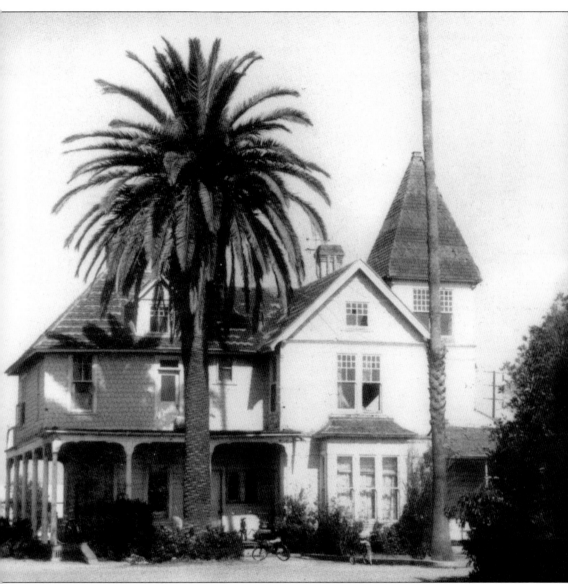

While most of Placentia's mansion-size ranch houses were built after 1900, a few had already been erected by then. One of the most ornate was this house of William Crowther, constructed in 1889. It has typical features of other large Victorian-era houses in the area, including the wraparound porch, clapboard exterior, and a steeply pitched roof. But it is unusual for also having a tall turret on one side. Crowther bought 130 acres in 1875 in the southwest part of Placentia. In addition to farming, he became prominent as a member of the first school board and later as a member of the Anaheim Union Water Company board. This photograph, taken in the 1930s, illustrates another increasingly popular feature of ranch houses: the use of palm trees as decorative foliage. Like most other ranch houses in the vicinity of Placentia Avenue, this was demolished to make way for commercial buildings or apartments. (Courtesy of Anaheim Public Library.)

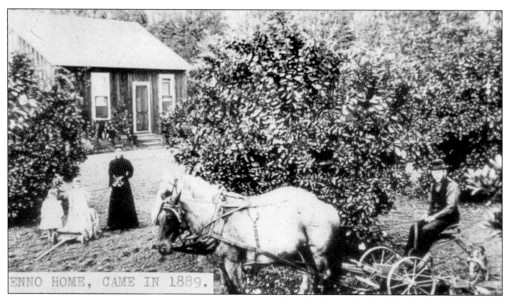

ENNO HOME, CAME IN 1889.

This 1897 photograph of the John Nenno family epitomizes the modest dwellings that many Placentia ranchers initially occupied. Nenno came to Placentia in 1892 and bought a small ranch from the "Grasseaters" colony. This three-room house had no water supply, and he had to haul water from over a mile away. In 1907, the Nennos replaced this structure with a large two-story mansion. (Courtesy of Placentia Public Library.)

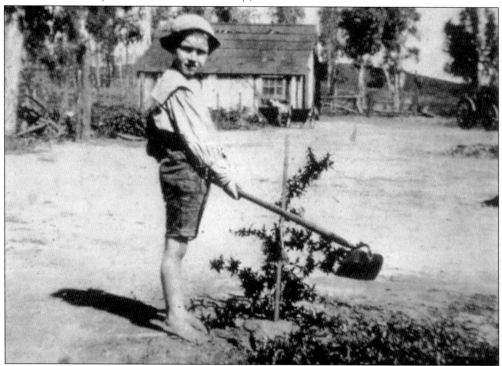

By the early 1900s, much of the Placentia area was still undeveloped. George G. Key, pictured here standing in his front yard, has only a wagon, a small barn, and imported Australian eucalyptus trees to modify the natural environment. (Courtesy of Key Ranch.)

Amid rural simplicity, some elegant mansions arose, such as this Italian Renaissance house erected by William Berkenstock in 1913. It featured marble fireplaces, stained-glass windows, and an unusually large and attractive front yard. Such luxuries came largely from his position as one of Orange County's leading fumigators. (Courtesy of Placentia Public Library.)

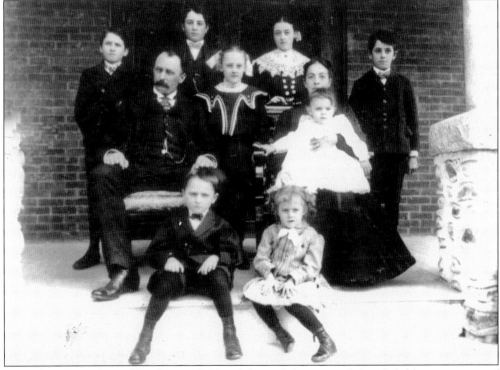

Samuel Kraemer, shown here (center, left) with his wife (center, right) and children, was a son of Daniel Kraemer. His wife was a granddaughter of Bernardo Yorba. Sam Kraemer inherited part of the family's land holdings and became one of the most prominent businessmen in Placentia. While he was a citrus rancher, he was also an active investor in real estate elsewhere. He donated land for the city's railroad depot, but he was most active in the development of Anaheim. Some of Placentia's earliest oil wells were also on his land. (Courtesy of Key Ranch.)

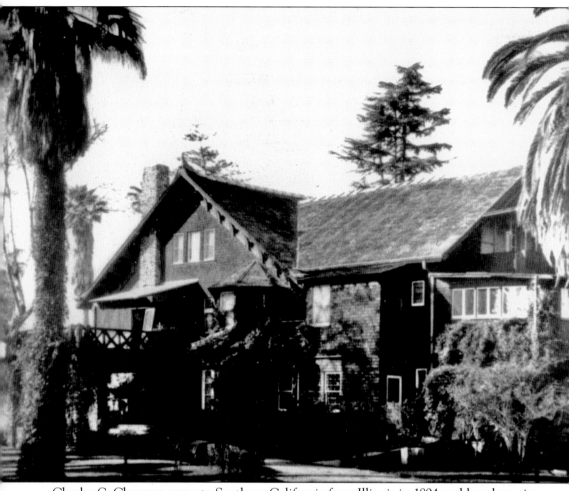

Charles C. Chapman came to Southern California from Illinois in 1894 and bought a citrus ranch on the edge of Placentia and Fullerton. Chapman's home, which sits along what is today State College Boulevard in Fullerton, was completed in 1903. It was one of the most expensive residences in the area, costing $15,000 and taking a year and a half to build. Its three stories contained 13 rooms, as well as a private electric plant. The building was neglected in its later years and burned down in 1959. (Courtesy of Anaheim Public Library.)

Chapman quickly amassed considerable wealth marketing his Valencia oranges by selectively sizing them and packing them in his own warehouse. Some of his extensive land holdings would also be the site of early Placentia oil wells. He soon identified himself mainly with Fullerton, becoming its first mayor in 1904. (Courtesy of Placentia Public Library.)

This photograph of the interior of the Chapman mansion shows the wealth of the larger ranchers in Placentia by the early 20th century. It also displays the eclectic interior design of ranch houses. Ottoman carpets lay underneath Victorian plush furniture and Spanish Revival ceilings. Some other residences, such as Bradford's, featured grandiose stairways and woodwork. All of these homes stood in striking contrast to the small, simple houses that many ranchers initially lived in. (Courtesy of Anaheim Public Library.)

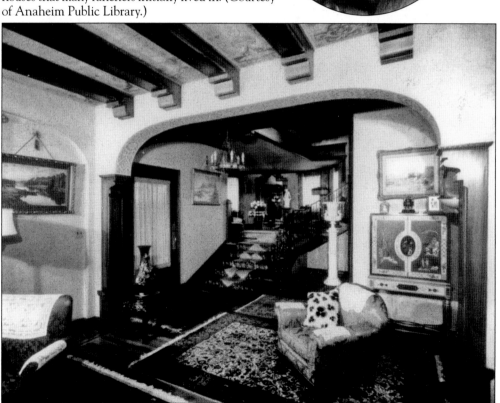

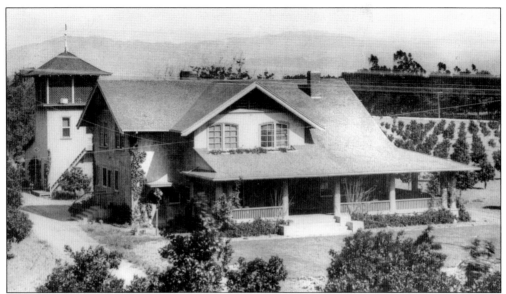

While few had houses as palatial as Chapman's, the children of several pioneer families built large and architecturally distinctive residences. One example was the Wagner family, whose three sons all set up prosperous ranches. This photograph, probably from the 1920s, is of the junior John Wagner's house, built in 1908. It reflects the Craftsman style and features the common water tower. This house is still an occupied residence on Valencia Avenue. (Courtesy of Placentia Public Library.)

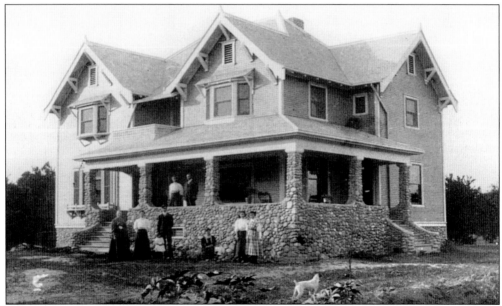

Stone figured in the second house built by John and Faustina Nenno in 1907–1908. Though this was probably taken shortly after the house was completed, this photograph of the building and family reflects the absence of landscaping in some otherwise ornate homes. John became prominent as a fumigator of orange groves as well as a rancher. Faustina was one of the founders of the Placentia Round Table. Modified into an office building, this house still stands on Palm Drive. (Courtesy of American Title Company.)

John Lemke emigrated from Poland and settled in Placentia in 1883. He bought a 20-acre ranch in 1902 and built this house the following year. An unusual feature was the construction of the first story in brick, which Lemke made. His family included eight children, one of whom, Lewis, built a Spanish ranch house in Placentia in 1922. This house was modified that same year, and both Lemke residences are Placentia historic landmarks. (Courtesy of Placentia Public Library.)

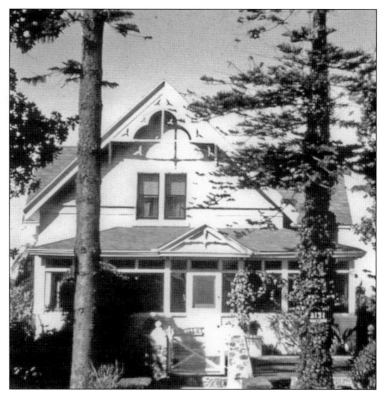

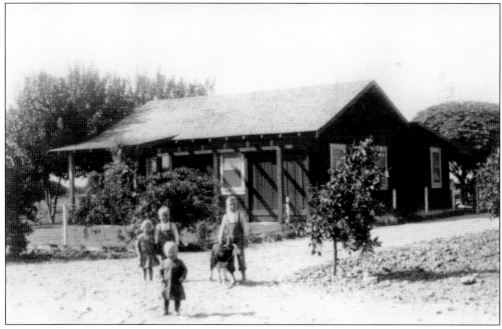

Placentia in the early 20th century had many more modest houses that continued the board-and-bat construction and the plain style of early residences. This 1912 photograph of the David and Lillie Wright home on Bastanchury Avenue was probably typical of such houses. None of these smaller structures have been preserved. (Courtesy of Placentia Public Library.)

One structure common to nearly all citrus ranches was a barn. A familiar style is seen in this photograph of A. S. Bradford's Tesoro Ranch barn. Barns were used as stables and for storage of equipment, vehicles, and crops. Like nearly all other barns and outer buildings in Placentia, this has been demolished. (Courtesy of Placentia Public Library.)

With the coming of the automobile, horses lost their role as the primary means of transportation, and many barns were at least partly converted into garages. A few lasted as such well into the 20th century. One of the last of these was this former barn on the Isabel Brower estate, seen in this picture shortly before its demolition in 2000. (Courtesy of John Walcek.)

# *Three*

# AGRICULTURAL
# DEVELOPMENT

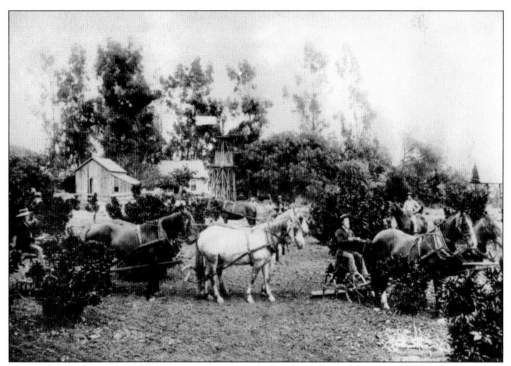

This photograph taken at the Chapman ranch *c.* 1894 is typical of much of Placentia as citrus growing became the main pursuit. Young orange trees stand before taller trees, possibly walnuts, which were grown in years before oranges became widespread. Eucalyptus in the background served as a windbreak. Three teams of horses may show cooperative farming among ranchers. They could also be an indication of C. C. Chapman's wealth. Such cultivation assured that irrigation water would sink into the ground to the roots. The buildings were similar to those on many beginning ranches, while the windmill and water tower were reminders of the importance of obtaining water beyond natural rainfall. (Courtesy of Key Ranch.)

This photograph of the Atherton Ostrich Farm in Fullerton in the late 1880s or 1890s is typical of much of the Placentia area at that time. Acres of grass (most likely barley, the most common commercial grain in north Orange County) are broken only by a few rows of trees. Extensive vegetable and fruit plantings would soon encompass much of Placentia, but landscapes such as this one would remain in some parts of it into the 20th century. (Courtesy of Key Ranch.)

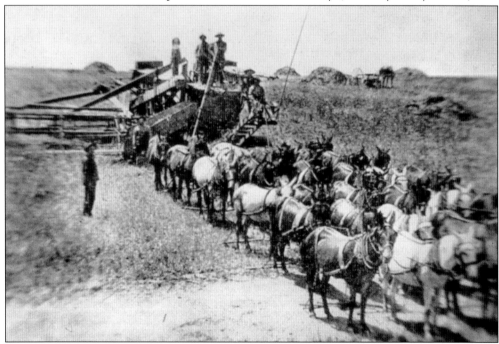

The importance of grain as a crop prior to citrus is illustrated in this late-19th-century photograph of the expensive equipment and animals farmers invested in (or rented). Since it could be grown without irrigation ("dry farming"), grain was a major crop before other sources of water were brought to the area. Mules shared the role of power source with horses. Haystacks like those in the background were common on early Placentia farms. (Courtesy of Key Ranch.)

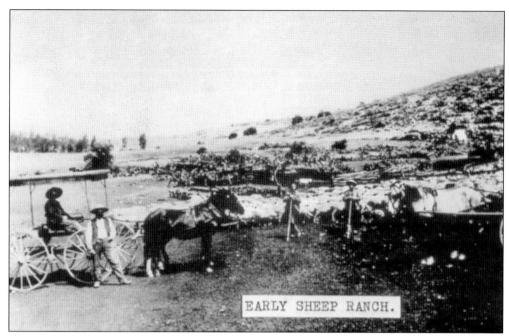

Sheep raising was especially pursued by European immigrants like the Wagners from Germany or the Basque Bastanchurys. As this late-19th-century photograph shows, it was especially prevalent in hilly areas. By the end of the century, both sheep and cattle grazing had been replaced by the growing of fruit trees in much of Placentia. (Courtesy of Key Ranch.)

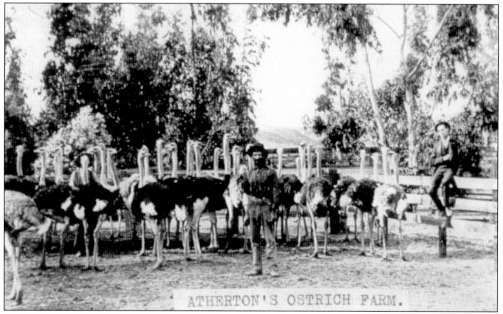

A more exotic type of livestock raised in Fullerton and Placentia was ostriches. The birds were brought to this area in 1886 by two South Africans, and their feathers were sought for women's hats. The most prominent farm, seen in this picture, was run by Edward Atherton. Placentia pioneer Sarah Jane McFadden also had an ostrich farm. The industry boomed in the 1890s and 1900s, but it collapsed when such hats went out of fashion. (Courtesy of Key Ranch.)

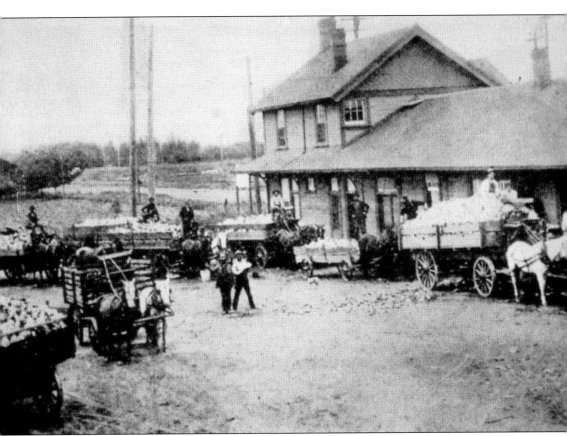

Vegetables vied with fruits to replace barley fields and livestock. This photograph shows cabbages being shipped from the Southern Pacific depot in Anaheim. Along with corn and potatoes, they were the main vegetable crop. By the early 1890s, a vegetable growers' union was formed in Placentia. Some ranchers, such as A. S. Bradford, planted cabbages between rows of citrus trees. Crops grown in Placentia were shipped from Anaheim or Fullerton until 1910, when a depot was built in Placentia. The town also had at least one cannery into the early 1920s, by which time vegetables had become a minor crop. (Courtesy of Anaheim Public Library.)

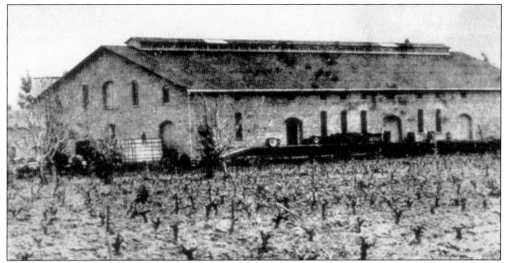

The earliest extensively grown fruit in Orange County was grapes. They were the mainstay of Anaheim, and the county once had 50 wineries. One was this brick building, constructed in Placentia about 1872 by Peter Hansen. Grape growing and wine making were virtually wiped out by a disease that swept through the county in the mid-1880s. (Courtesy of Key Ranch.)

Walnut groves, such as the one in this picture, were another popular form of agriculture in Placentia in the late 19th century. Ranchers like Crowther made walnuts their main crop, and Placentia had a walnut growers' union. This crop peaked in the 1880s, probably the date of this photograph, when soft-shelled nuts were introduced. Because nuts were shaken from trees, children often harvested them—so much so that schools delayed opening until the walnut season ended. Hit by disease in the 1890s, Placentia's walnut industry declined and all but ended by 1930. (Courtesy of Placentia Public Library.)

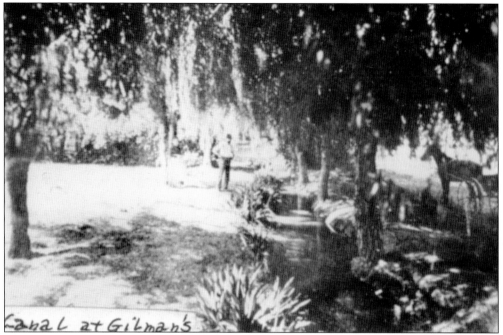

Canal at Gilman's

Additional water was essential to fruit and vegetable farming. While windmills attest to the use of artesian wells, the Santa Ana River was the major source of water. Early irrigation works, such as this one at Gilman's ranch, were simple dirt ditches. Pathways often paralleled them, and vegetation thrived along their banks. (Courtesy of Placentia Public Library.)

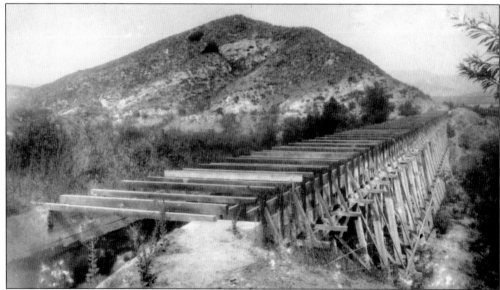

Water was carried from the Santa Ana River to the Placentia–Yorba Linda area via the Cajon Canal. It was begun in 1875 by a group of ranchers and businessmen, mostly from Placentia. Its location along hilly ground necessitated building flumes, such as the one shown here, across ravines. The canal was 15 miles long, much of it dug by imported Chinese laborers. The canal remained the major source of water for parts of north Orange County for decades. (Courtesy of Placentia Public Library.)

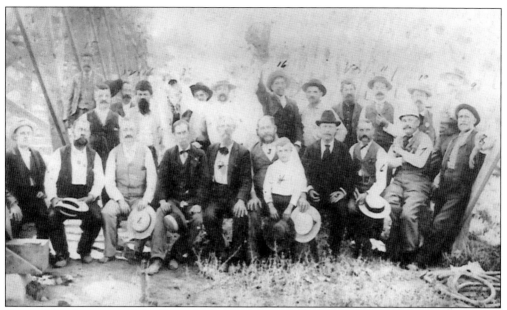

Some of the financiers of the Cajon Irrigation Company are seen at this opening of the canal in 1878, in front of Flume No. 8. Financial problems forced a merger that formed the Anaheim Union Water Company. It had extensive land holdings in northwest Placentia, but legal issues over the right to water troubled the company until 1899. (Courtesy of Placentia Public Library.)

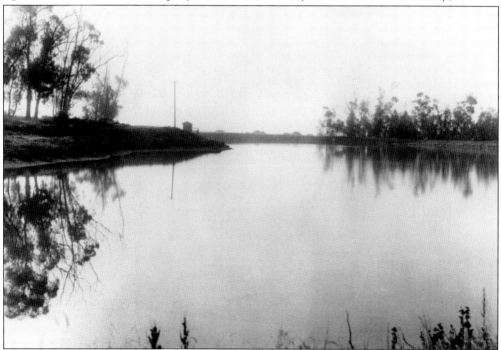

The Cajon Canal emptied into the reservoir shown in this photograph. Often called Tuffree Reservoir because half of it was on that family's land, the whole area was acquired by the Anaheim Union Water Company and later by the City of Placentia. In the 1970s, it became Tri-City Park, developed in conjunction with Brea and Fullerton. (Courtesy of Placentia Public Library.)

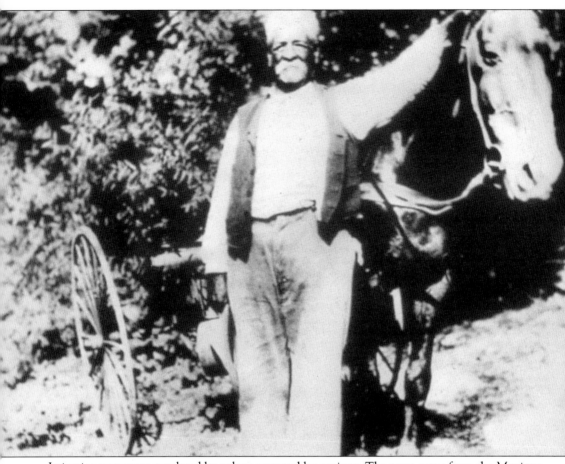

Irrigation water was regulated by valves operated by *zanjeros*. The term came from the Mexican era, and many Latinos continued to hold this job. The chief *zanjero* for the Anaheim Union Water company was Rafael Navarro, shown in this 1890s photograph with his horse Tom and the buggy he took between gates. He was a descendant of Juan Antonio Navarro, a member of Portola's expedition. (Courtesy of Anaheim Public Library.)

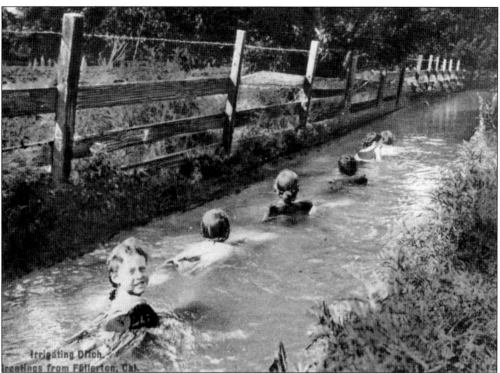

Irrigating Ditch.
Greetings from Fullerton, Cal.

Irrigation ditches could be fun as well as fertilizing. This undated photograph is in Fullerton, but memoirs of Placentia residents like George G. Key and Alfred Aguirre recount that these ditches were swimming holes there, too. While the bathers in this picture appear to be well clad, Key recalls that male swimmers in Placentia's ditches were "not only topless but were also bottomless." (Courtesy of Fullerton Public Library.)

This plaque at Cal State Fullerton commemorates planting the first commercial Valencia orange grove in California in 1880. While other varieties of orange had been grown locally, the Valencia proved the most successful. With the decline of other fruits from disease and the development of cooperative-marketing organizations, the Valencia orange became the mainstay of Placentia's economy. (Courtesy of Placentia Public Library.)

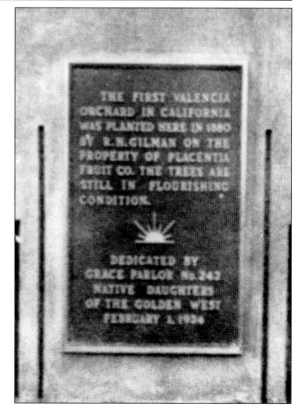

This 1880s photograph is of Richard Gilman's Southern California Semi-Tropical Fruit Company. Founded in 1872, it was the first place to grow Valencias commercially. The man in the buggy is George Amerige, a founder of Fullerton. This photograph shows a variety of trees and a disorderly pattern of planting compared with many later citrus groves. (Courtesy of First American Title Company.)

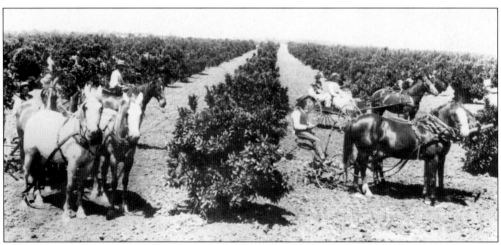

This 1894 shot of the Chapman ranch epitomizes the growth of citrus farming by that decade. Obviously young trees stretch to the horizon. Scenes like these would become the dominant landscape, even when legally they represented several ranches. Horses were equally common in all aspects of citrus farming, from cultivation to market transportation, into the 20th century. (Courtesy of First American Title Company.)

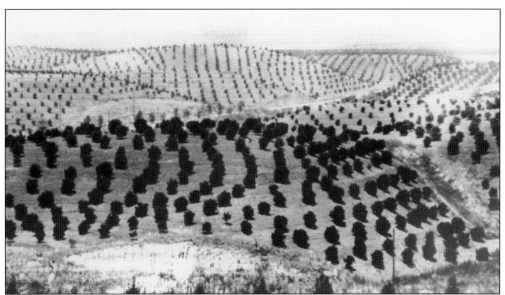

Hills on the east side of Placentia were planted later than level areas, but, by the early 1900s, that area was also covered with trees. Prominent ranchers like Chapman and Samuel Kraemer had large holdings in this area. The absence of other trees in this early 1900s photograph illustrates how exclusively Placentia ranchers concentrated on Valencias by this time. (Courtesy of Placentia Public Library.)

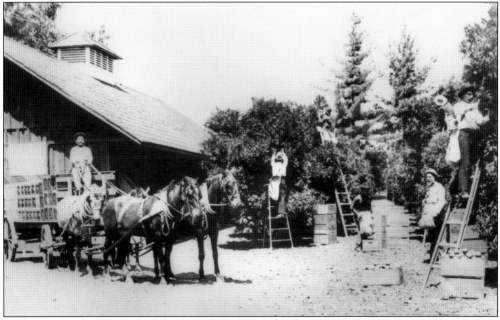

This photograph shows several components of citrus farming. Pickers carried sacks on shoulder straps and worked from ladders often supported solely by trees. Wooden crates could weigh 60 pounds when full and were hauled either into the barn or directly to packinghouses. This photograph suggests the latter, since boxes on the wagon have labels that were associated with packinghouses, which were not widely used until the 20th century. (Courtesy of First American Title Company.)

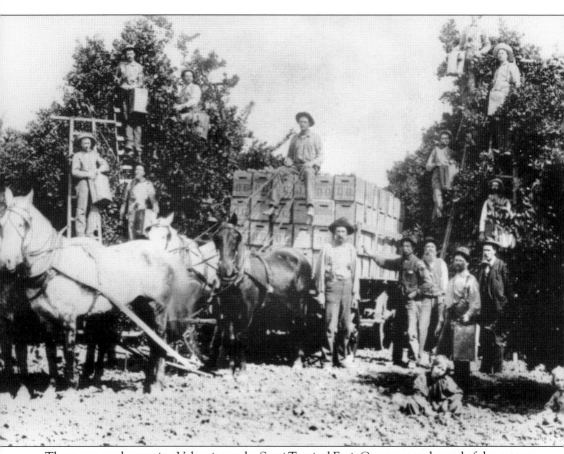

These men are harvesting Valencias at the Semi-Tropical Fruit Company at the end of the century. Renamed the Placentia Fruit Company in 1897, it was one of the earliest examples of company farming in Placentia. That all the workers appear to be white has two explanations. Chinese workers had been harassed and become increasingly unwelcome in Placentia, but Japanese workers were only beginning to arrive (and were not a sizeable part of Placentia's laborers). Mexican immigration was still small. The other explanation is that some of these men are not ordinary citrus pickers. George B. Key (center) managed the Gilman ranch, and Andrew Ipsen (in tree, left) was a prospective businessman and future member of the city council. (Courtesy of Key Ranch.)

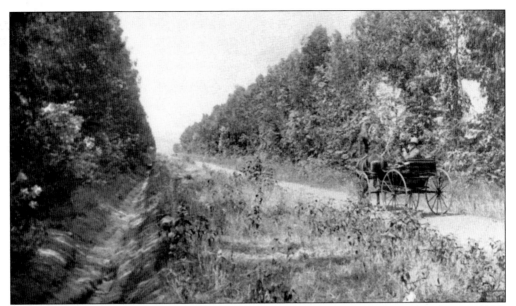

Most roads in Placentia were similar to this photograph of "Eucalyptus Avenue" from c. 1900. Unpaved, they were dusty much of the year and could be impassably muddy in the winter. But this primitive transportation network satisfied Placentia's needs into the 20th century. (Courtesy of Fullerton Public Library.)

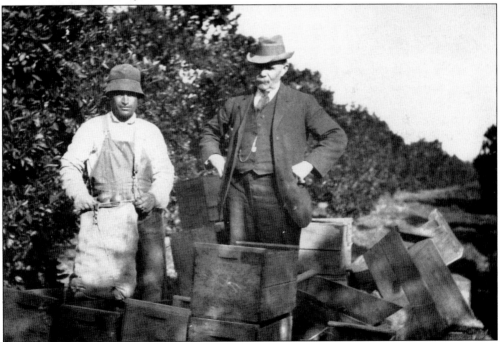

Citrus ranchers by the early 1900s had become less family farmers and more industrial managers. In this photograph of grower Alexis Pendleton and a picker on his 40-acre ranch in northwest Placentia, the contrast in dress reflects different roles and status. Setting wooden packing boxes at the end of rows in the early morning for pickers was common practice. (Courtesy of Placentia Public Library.)

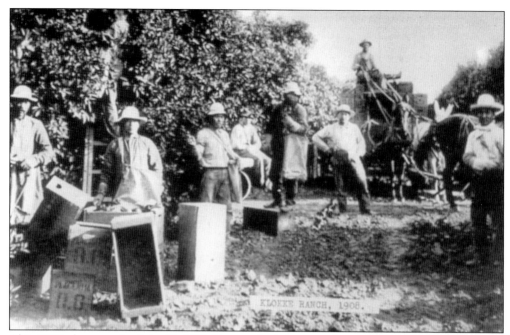

This 1908 photograph of the Earl Klokke ranch shows an ethnic diversity in workers. Some are white, some appear Asian, some Latino. It was not common to see such a mix in one grove. The inscription on the box ends, "Placentia O[range] G[rowers]," showing the importance of Placentia's first cooperative marketing association, formed in 1894, in handling the marketing and transportation of fruit. (Courtesy of Key Ranch.)

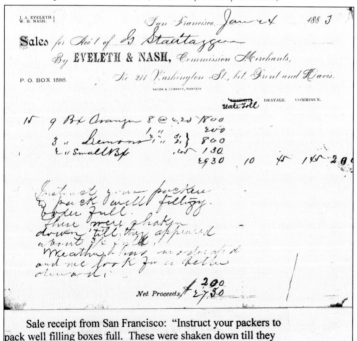

Sale receipt from San Francisco: "Instruct your packers to pack well filling boxes full. These were shaken down till they appeared about ¾ full. Weather has moderated and we loof for a better climate."

This 1883 bill of sale between a Southern California grower and San Francisco merchants shows that early ranchers sold their fruit through independent commissioners. Lemons were the second largest citrus crop but were much less common. Such bills often contained admonitions such as in this one: "Instruct your packers to pack well filling boxes full. These were shaken down till they appeared about 3/4 full. Weather has moderated and we loof [sic] for a better climate." (Courtesy of California State University, Fullerton.)

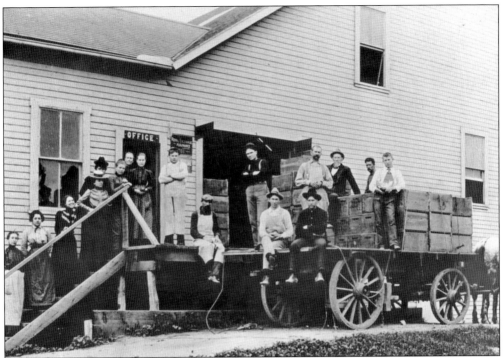

A key element of the citrus-marketing system that was developed in the 1890s was the local packinghouse. It eliminated bargaining with individual and often distant merchants. This photograph is of the one the Placentia Orange Growers Association built in 1894 in Fullerton, then the closest rail depot. The women on the steps may have packed oranges, though men more often did that work at this early stage of the industry. (Courtesy of Fullerton Public Library.)

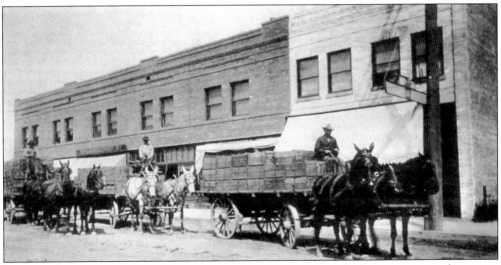

The output of one ranch is illustrated in this 1907 photograph of mule-drawn wagons in downtown Fullerton. All the crates are from the Nenno ranch in Placentia. This picture also illustrates the strength and endurance of mules and horses, in that each team could haul four tons of crated fruit, plus the wagon and driver. (Courtesy of Key Ranch.)

While much of Placentia was growing groves of oranges, some parts, such as the one in this photograph of Atwood in 1904, were relatively barren. The haystack to the right of the barn suggests this was a barley field. The white house shows that the landowners shared the prosperity if not the environmental beauty of citrus ranches. (Courtesy of Placentia Public Library.)

# *Four*

# RURAL LIFE AND EARLY SCHOOLS

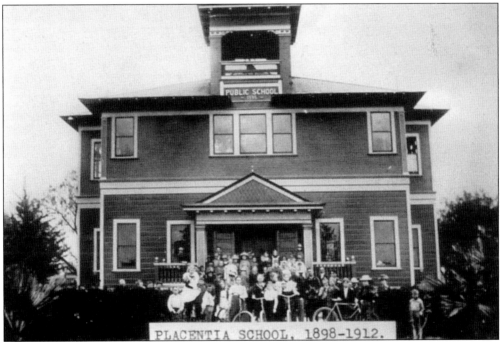

PLACENTIA SCHOOL, 1898–1912.

Up to 1910, Placentia was a land of scattered farms, and only occasionally did many of its residents come together in formal activities. It had no urban area and only a few community institutions, most of which, like growers associations, were linked to the economy. One base Placentia had for building a community was its public school. Its residents had access to a school from the 1860s, and by 1884, a school building was located in what would become the town. This photograph shows the Placentia Grammar School as it was rebuilt in 1898. The students spanned eight grades and were initially all in one room. Many of Placentia's future leaders were educated in this school, and some of its prominent pioneers served on the school board. Board elections and school-bond issues were among the leading civic events. The building also was used as a Sunday school and as a church. In these and other ways, the Placentia Grammar School was a foundation of community life and development. (Courtesy of Key Ranch.)

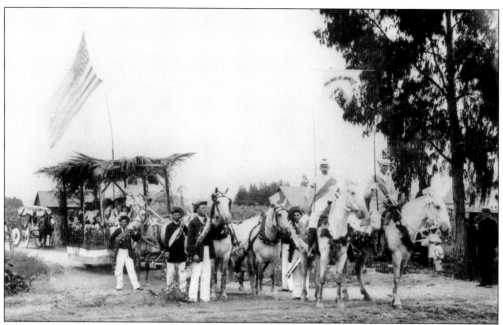

Placentia residents did put on occasional parties, balls, and celebrations. Some of the most spectacular events in early years were in neighboring cities, like this float of a tropical scene displayed at a 1900s Fourth of July parade in Fullerton. Two of those leading the horse team were rancher John Lemke and his daughter. (Courtesy of Key Ranch.)

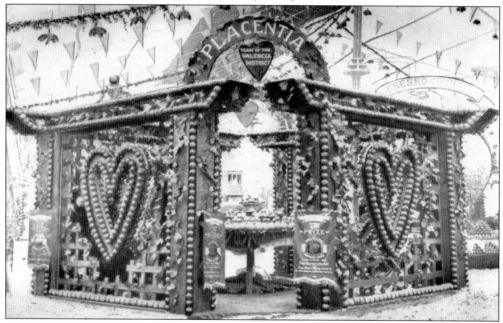

Agricultural exhibits were another event in which Placentia residents participated. They also were mostly held in urban areas, as in this photograph of Placentia's exhibit at a San Bernardino County Fair c. 1910. It was organized by the newly formed chamber of commerce. Both the lavish decoration and the "Heart of the Valencia District" logo reflect the pride that Placentia took in its Valencia orange industry. (Courtesy of Placentia Public Library.)

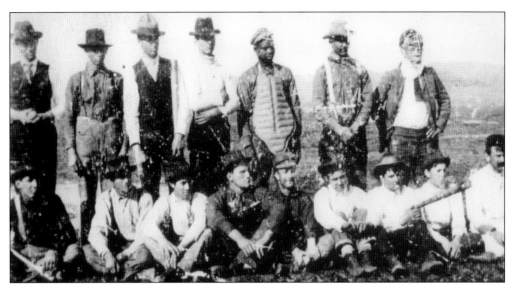

Sports brought farm families together, often in inter-community matches. This photograph of the Placentia baseball team in 1898 features children of at least four prominent rancher families (Hetebrink, McFadden, Tuffree, and Wagner). This team is unusual for including an African American, a race that would be largely absent from Placentia (and many adjacent communities) well into the 20th century. (Courtesy of Placentia Public Library.)

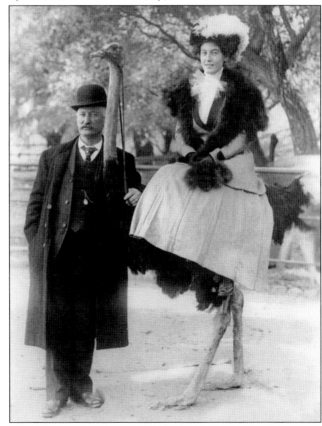

Fancy dress is not usually associated with farms, but they mixed in early Placentia. Ostrich farms provided both some of the fanciness and a unique type of social outing. The man in this photograph from the first decade of the 20th century may be Charles C. Chapman. (Courtesy of John Walcek.)

47

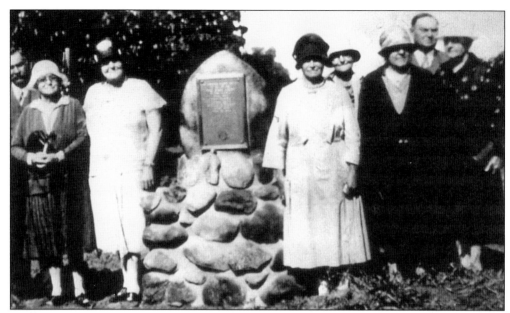

The area that became Orange County set up two schools in 1854. The more northern one, the Upper Santa Ana School, split, and in 1870, the northern part of that authorized a school near Placentia, on the south side of the Santa Ana River. Known as the Old Yorba School, it was attended by children of several pioneer Placentia families. The building was abandoned later in the century, but in 1929, a plaque marking its location was dedicated. (Courtesy of Key Ranch.)

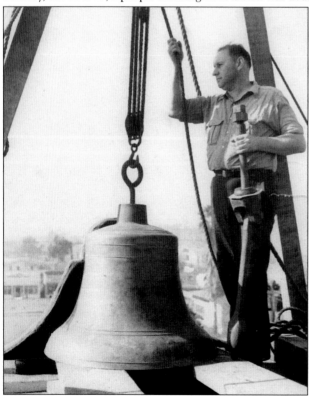

Both of Placentia's earliest schools had conspicuous belfries from which a large bell announced the start of school. How far could that bell be heard? Note its size in this photograph. It was made in 1884 and weighed 128 pounds. When the grammar school was abandoned in 1912, its lumber and the bell were transferred to the first Placentia Presbyterian Church, where the bell still hangs. (Courtesy of Placentia Presbyterian Church.)

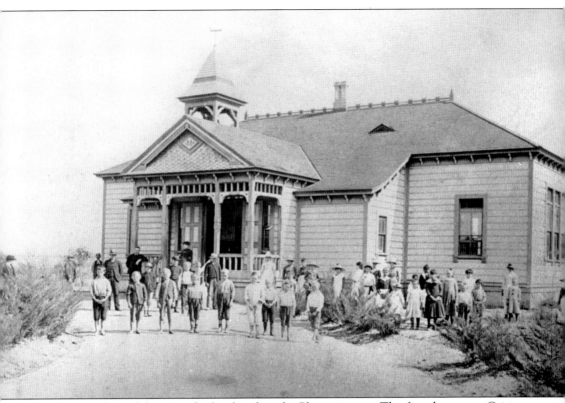

This photograph is of the second school within the Placentia area. The first, known as Cajon (sometimes El Cajon) School, was built in 1874 under the supervision of William McFadden. It had one classroom for students ranging from 6 to 18. In 1878, several ranchers moved it to what is today the corner of Chapman and Placentia Avenues. In 1879, the school district was renamed Placentia, and the school was accordingly called Placentia Grammar School. In 1884, this two-room building was constructed to replace the original school. This photograph was taken before 1898, when this building was enlarged. (Courtesy of Placentia Public Library.)

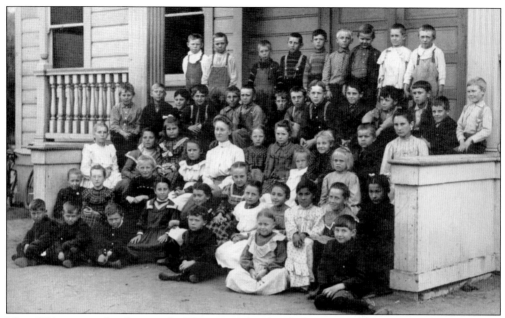

This 1904 picture of students at the Placentia School includes many ranch families and individuals who would become prominent in the town. The teacher in the center (white dress) is Cora Evans. Bicycles, such as the ones pictured at left, were one means of getting to school. A student stable behind this building indicates another. (Courtesy of Placentia Public Library.)

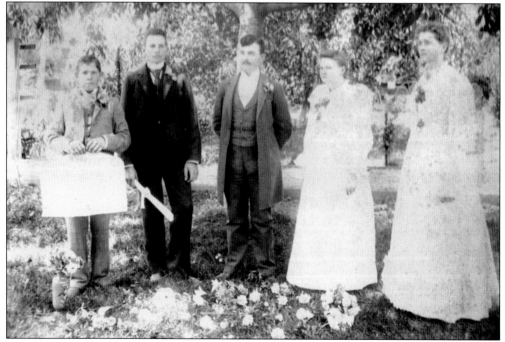

This photograph is of the first graduating class from the Placentia School, probably about 1893. Considering that classes were only offered through grade eight (which is all state law then required), most of these students appear to have either started school late or to have taken more than one year to complete a grade. (Courtesy of Key Ranch.)

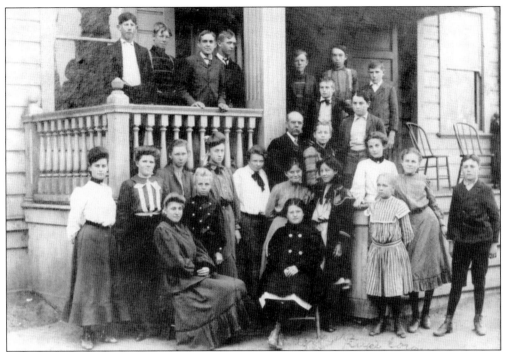

Enrollment at the Placentia Grammar School grew, and by the early 1900s, the graduating class numbered 24 students, as seen in this photograph. It is interesting that girls slightly outnumber boys and that all students (with one possible exception) are Anglo. The area at this time had a small Latino population, most of whom rarely completed eight years of school. (Courtesy of Placentia Public Library.)

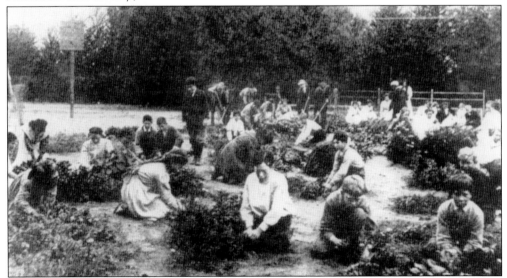

Placentia's schools fit in well with its agricultural economy. School grounds were large enough to allow children to practice gardening, as this photograph shows. The school year was sometimes modified to accommodate children working on harvests. This photograph was probably taken around 1910, when basketball was set up on campus, as evidenced by the hoop in the background. (Courtesy of Placentia Public Library.)

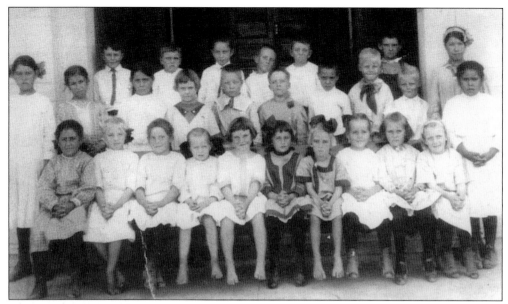

This photograph of children on the steps of the Placentia School *c.* 1910 shows only a portion of that school's enrollment, which reached 125–150 by that year. This number, compared with over 200 children living in Placentia at that time, suggests that not all children regularly attended school. The dress code apparently called for dresses and full shirts but left footwear optional. (Courtesy of Key Ranch.)

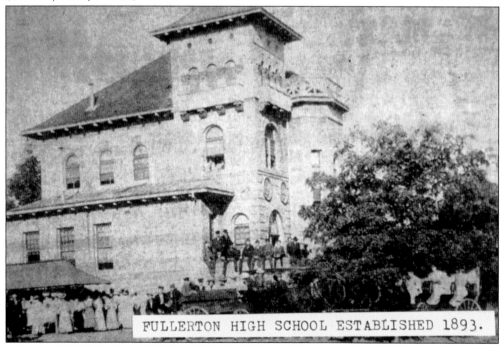

FULLERTON HIGH SCHOOL ESTABLISHED 1893.

Fullerton High School was built in 1893, the same year Placentia joined Fullerton in forming a Union High School District. This building and its successor provided Placentia residents with public education beyond the eighth grade into the 1930s. This building was replaced by a more modern, concrete structure in 1908. (Courtesy of Key Ranch.)

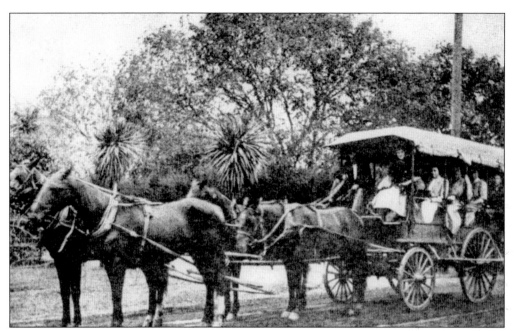

The trip to Fullerton High was several miles each way, so the district provided the horse-drawn bus shown in this photograph. Not all teenagers attended high school, but those closer to it walked or biked there. (Courtesy of Placentia Public Library.)

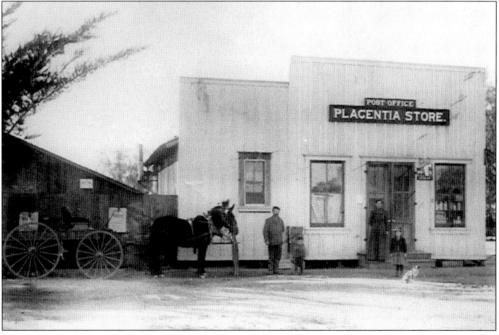

This photograph is of the first store in Placentia, established in 1897. It was also the second location of Placentia's post office, which had been authorized in 1893. When the first postmaster resigned, Clara Wetzel offered to combine that job with opening a store on the Placentia School grounds. Placentia replaced its post office with rural free delivery from Fullerton between 1902 and 1914. (Courtesy of Placentia Public Library.)

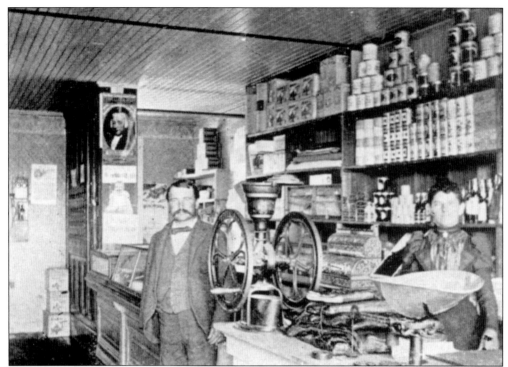

This photograph of the interior of Wetzel's store shows both Hugo and Clara and their stock of dry goods. Mailboxes in the background define the post office. Wetzel sold this store in 1900, and it was moved off school land. It became the Placentia branch of the Fullerton Stern and Goodman store. (Courtesy of Placentia Public Library.)

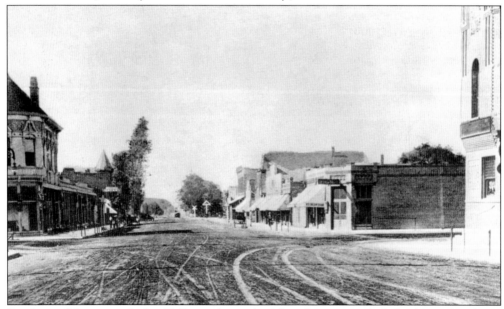

Residents of Placentia relied on Fullerton for much of their shopping and wholesale merchandising until 1910. That town developed a substantial downtown business district, as this early-20th-century photograph of Spadra Road (Harbor Boulevard) shows. (Courtesy of Fullerton Public Library.)

In 1902, a group of Placentia women founded one of the earliest social organizations, the Round Table Club. Composed of wives of many prominent ranchers, it began in private homes and focused on cultivating interest in literature. Subsequently it also went into service work. The building shown in this photograph was built in 1911–1912 along Chapman Avenue. A new club house was dedicated in 1967, and the organization still thrives. The water towers behind it were built by the Placentia Domestic Water Company, organized by A. S. Bradford. They provided water and fire protection to the emerging town. A larger single water tower still stands on the same site. (Courtesy of Placentia Public Library.)

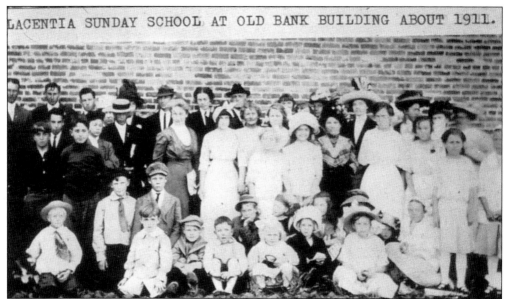

Placentia had no organized church or church building before about 1910. Religious activities were led by visiting preachers and priests, who periodically held services, and by residents, who organized a Sunday school and occasional camp meetings. The former usually met at the grammar school, the latter in the groves. But by 1910, with the construction of commercial buildings, Sunday-school classes had more places to meet, such as the one in this photograph at the Bank of Placentia Building. (Courtesy of Placentia Public Library.)

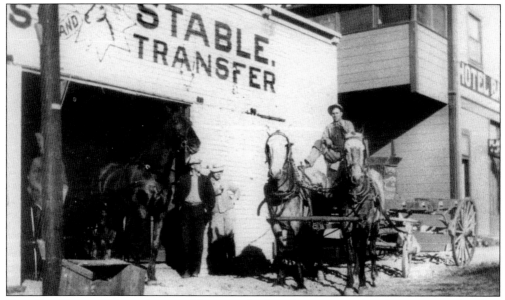

Not all residents of Placentia owned horses or had carriages appropriate for various tasks. This is why the livery stable was an essential part of the community. It was to an era of horse-drawn transportation what a car rental agency is today (except that the "motor" and the vehicle could be rented separately). This photograph is of a business in downtown Placentia set up about 1911 by Otto Schaller, the son of a German immigrant who came to Placentia in 1888. (Courtesy of Key Ranch.)

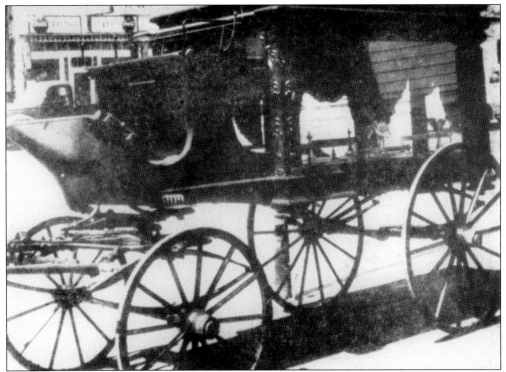

Horse-drawn carriages fulfilled many functions that motorized vehicles subsequently took over. One of these was transporting the deceased, as this photograph of a hearse in Placentia shows. The black color indicates that this hearse was for an elderly person. Had the deceased been a young adult, it would have been grey; had the deceased been a child, it would have been white. (Courtesy of Placentia Public Library.)

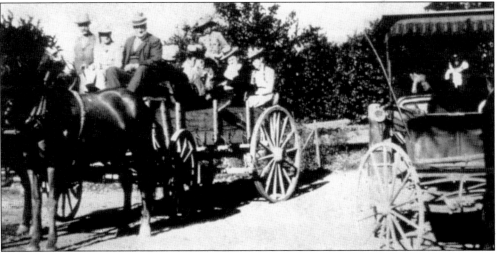

This picture of the family of George B. Key going out on a picnic in 1901 shows the multiple uses that were made of horse-drawn vehicles. The surrey on the right was the more fashionable vehicle, but it could hardly hold the nine people crowded into the wagon that at other times served as a freight vehicle. Whether moving people or crates, two horses were expected to deliver the power of modern automobile engines. (Courtesy of Key Ranch.)

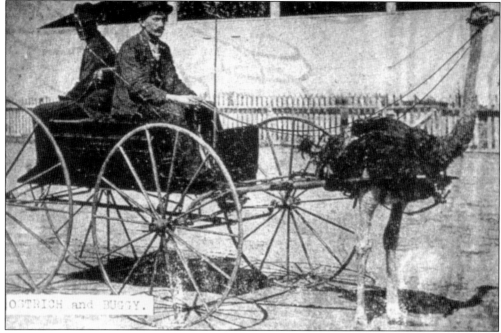

While horses and mules moved most vehicles until the 1900s, this photograph taken at the Fullerton ostrich farm around 1900 suggests that alternatives could at least be demonstrated. This photograph also illustrates a basic buggy, which was the most common horse-drawn personal vehicle of its time. (Courtesy of Placentia Public Library.)

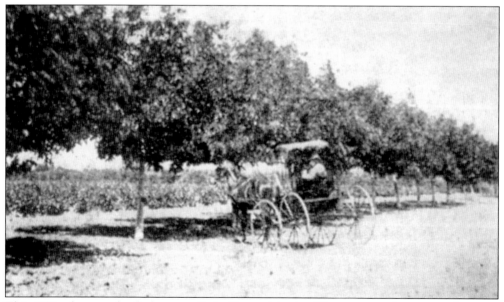

This 1880s photograph of a buggy pulled off a road in the Gilman grove shows one advantage of horse-drawn vehicles: the road system they needed required only minimal effort to set up and maintain. Even the "pollution" that horse power emitted blended into the road in a short time. (Courtesy of Placentia Public Library.)

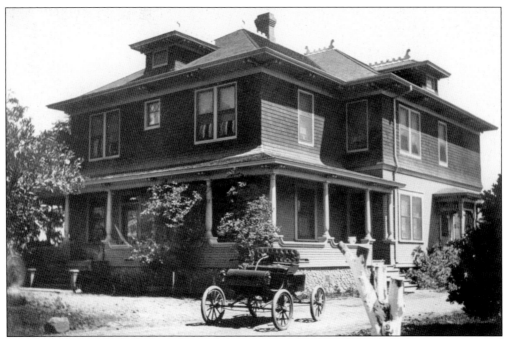

By the early 1900s, automobiles were coming to Placentia. Two of the first to own them were Thomas Strain and A. S. Bradford. The car of the latter is in this photograph in front of his house. Such early models used most of the features of horse-drawn carriages and lacked steering wheels and windshields. They were bedeviled with flat tires well into the second decade of the 20th century. (Courtesy of Placentia Public Library.)

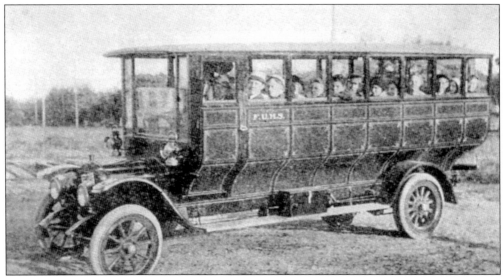

This photograph of a Fullerton Union High School bus *c.* 1913 shows that the replacement of horse-drawn by motorized vehicles had extended by this time from personal to public carriers. This bus also shows a closed-carriage, windowed design much more in line with future motorized vehicles than with carriages of the past. It is not known if any such buses were set aside exclusively for Placentia students, but their size, compared with horse-drawn buses, suggests a growing high school population. (Courtesy of Key Ranch.)

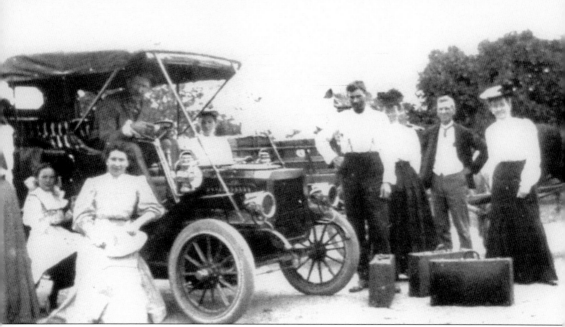

By the second decade of the 20th century, many Placentia residents, as in this picture of George B. Key's family, were going out in automobiles. The family is posing next to their 1907 Reo. But the transition from horse to motor was gradual, and the horse-drawn wagon in the background indicates that both modes of transportation coexisted for years. By this time, automakers had replaced steering levers with wheels but typically positioned them on the right side of the car. (Courtesy of Key Ranch.)

*Five*

# TOWN, TRADE, AND TRANSPORTATION

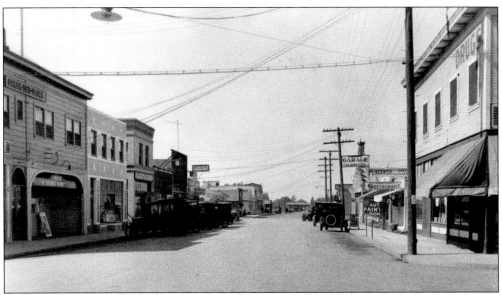

In 1910, Placentia was transformed from a totally rural area to one with a small town. The catalyst for this change was the building of a track linked to the Atchison, Topeka, and Santa Fe (AT&SF) route in Orange County. A depot was built along the tracks, and a town was platted north of them. Part of this plan was a commercial strip named Santa Fe Avenue, seen in this *c.* 1920 photograph looking west along that street from the first block west of the depot. Most business enterprises in the Placentia area for several decades were set up along this street. Service garages, the rows of parked cars, and the absence of horses signify the coming of a new mode of transportation. The railroad was most important for providing local growers with a convenient outlet for their citrus crops, as several packinghouses were quickly built south of Santa Fe Avenue. (Courtesy of Placentia Public Library.)

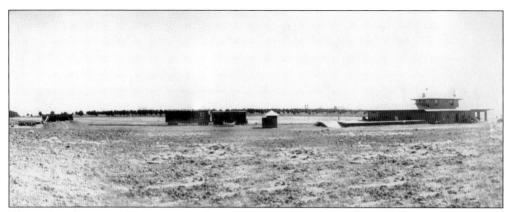

The railroad came to Placentia thanks to a group of ranchers, along with attorney Richard Melrose, who raised funds to buy the right-of-way for tracks. Samuel Kraemer dedicated the land on which the depot (right) was built. As this 1910 photograph shows, the area was barren, with little sign of a future town. It had long been leased for growing barley. The first train arrived in June 1910, and freight service was begun immediately. The decline of people traveling by rail led to the end of passenger service in Placentia in 1969 and to the bulldozing of the depot in 1971. (Courtesy of Placentia Public Library.)

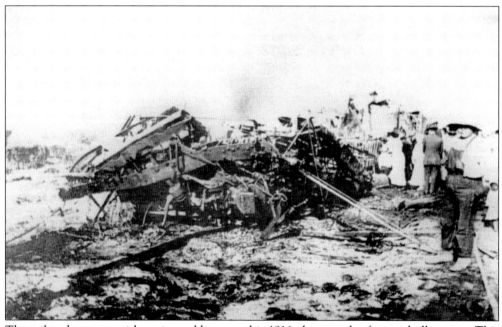

The railroad was not without its problems, as this 1916 photograph of a wreck illustrates. This accident occurred at Yorba, a few miles east of Placentia, when an oil-tank car broke away and rolled down a side track into a passenger train. Looking at the mangled railroad cars, it is hard to believe that only three people died. (Courtesy of Key Ranch.)

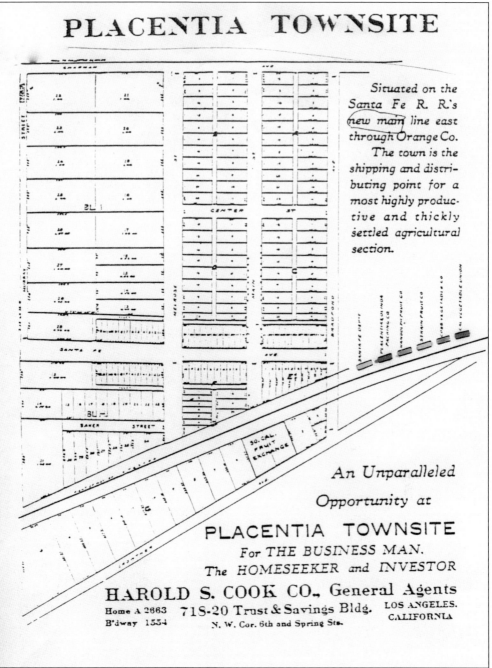

# PLACENTIA TOWNSITE

Situated on the Santa Fe R. R.'s new main line east through Orange Co.

The town is the shipping and distributing point for a most highly productive and thickly settled agricultural section.

An Unparalleled

Opportunity at

## PLACENTIA TOWNSITE

For THE BUSINESS MAN.
The HOMESEEKER and INVESTOR

## HAROLD S. COOK CO., General Agents

Home A 2663    718-20 Trust & Savings Bldg.    LOS ANGELES.
B'dway 1554    N. W. Cor. 6th and Spring Sts.    CALIFORNIA

After securing the railroad, Richard Melrose and A. S. Bradford arranged for a town to be platted. This 1911 advertisement shows the distinct packinghouse, commercial (narrow lots on Santa Fe), and residential areas. The role of wealthy residents in making the town was recognized in the names given to the four boundary streets: Bradford, Melrose, Crowther, and Chapman. The town grew little for several decades, encompassing less than one-fifth of a square mile when it was incorporated in 1926. Nearly all of the orange groves around it remained outside the incorporated area until the 1960s. (Courtesy of Placentia Public Library.)

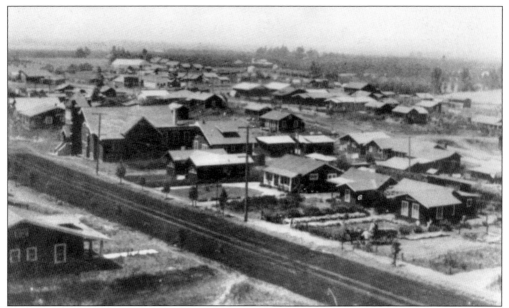

Placentia soon added residential housing to round it out as a town. This photograph, taken *c.* 1915, is looking north of the business district on Santa Fe Avenue. At the left center is the Presbyterian church, dedicated in 1913. Most houses were single-story wood frame, smaller than the homes of leading ranchers. Horse-drawn wagons, such as the one in the right foreground, were still common. Most of Placentia's residential housing would be in this area for several decades. (Courtesy of Placentia Public Library.)

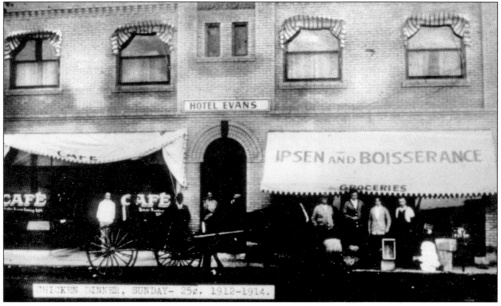

The Marjie Building, shown in this picture from around 1910, was one of the earliest structures on Santa Fe Avenue. Built in 1911, it was one of several brick buildings that still stand and that have been recognized as city landmarks. Its hotel was one of three. The Ipsen and Boisseranc [misspelled on the awning] store had relocated from the school grounds and would later be known as the People's Store. (Courtesy of First American Title Company.)

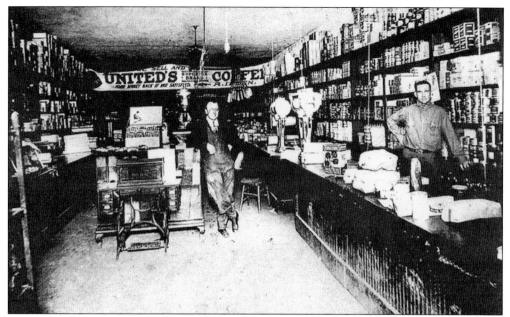

The People's Store featured most of the goods of a full grocery store of the early 20th century. Andrew Ipsen is in the center. This store soon had at least one competitor, the Dependable Store, which was founded by Jesse Payne and which also served as the town's post office. (Courtesy of Key Ranch.)

A mainstay of the early town was the bank building, shown here in a 1970s picture after it had been closed as a bank. It was initially the Placentia National Bank, run by A. S. Bradford and several fellow ranchers. In 1925, it was sold to the Bank of Italy, which in 1930 became Bank of America. Its second story temporarily housed several community organizations and later the city government. (Courtesy of Placentia Public Library.)

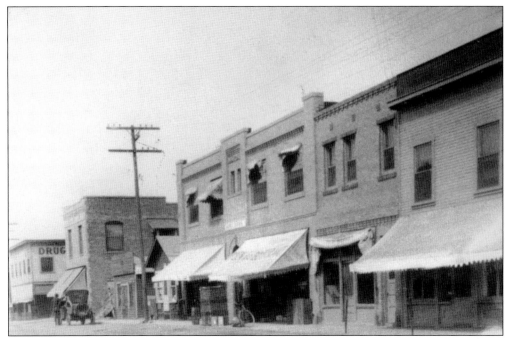

This shot of the north side of Santa Fe Avenue in the 1920s shows a mix of wood and brick construction, which would change as more substantial structures replaced wooden ones. Torn awnings suggest early deterioration or neglect by owners. (Courtesy of Placentia Public Library.)

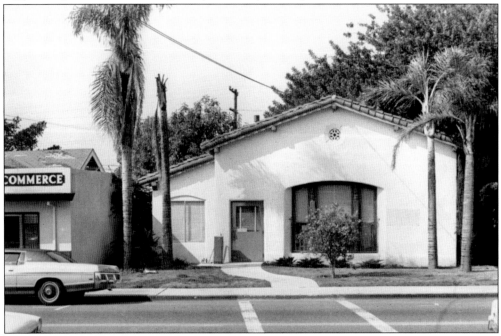

A few commercial establishments were located on Bradford Avenue, and among them was the telephone company, which built this office there in 1930. Nine years later, its Spanish Revival style was imitated in the city hall directly across the street. This building had several later users and has been upgraded by the users. (Courtesy of City of Placentia.)

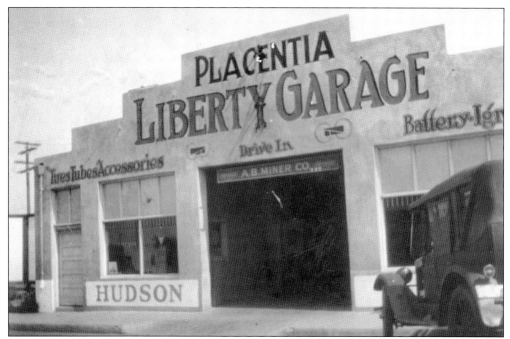

This photograph, taken c. 1920, shows one of at least three garages in the downtown area. These services for automobiles seem to have coexisted for some time with the livery and stable just south of Santa Fe Avenue. (Courtesy of Placentia Public Library.)

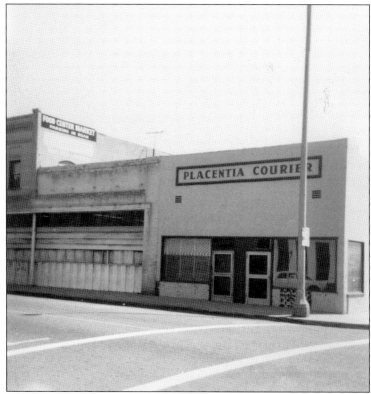

Placentia acquired its first and, until 1970, its only newspaper when Bradford persuaded a journalist to put up a print shop and start the *Placentia Courier*. It went through several owners and locations until 1928, when Frank Rospaw bought it. His family ran it until 1973. This post-1960 photograph shows one of the paper's last locations. (Courtesy of Placentia Public Library.)

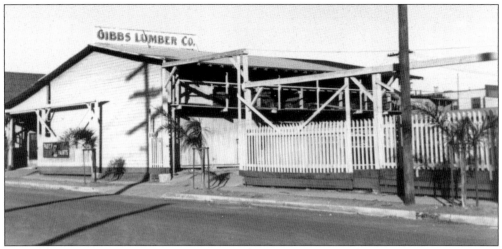

One of the town's first establishments was a lumber company, located near the tracks. In 1911, it became Gibbs Lumber, which also had yards in Anaheim and Fullerton. As this 1950s photograph attests, it remained a source of lumber in Placentia for many years. (Courtesy of Placentia Public Library.)

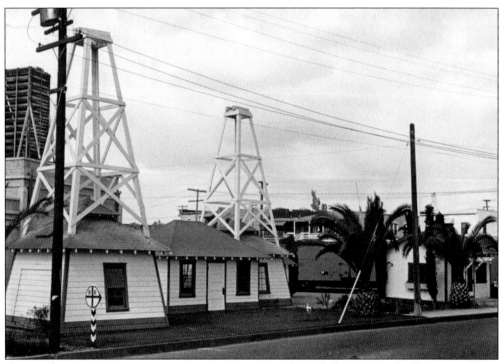

Among the more interesting structures in town were these, belonging to the Domestic Water Company, which was later known as the Placentia Water Company. The towers date from the 1920s and held pumps that sent water to the city's water towers. This facility served city households, while the Tuffree Reservoir met ranchers' needs. The towers have been removed. (Courtesy of Placentia Public Library.)

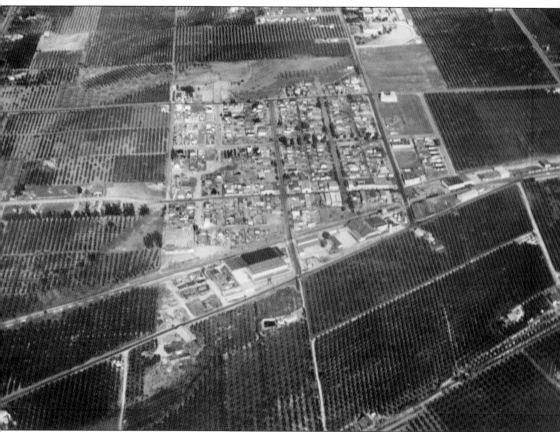

The town of Placentia is placed in perspective to its surroundings in this 1930s photograph. Valencia High School and a small tract west of it were recent additions to the core town, which is surrounded by miles of orange groves and occasional ranch houses. The cleared area south of Calvary Church (white building at the right side of town) would soon be occupied by a city hall. Otherwise, Placentia changed little from its original boundaries through World War II. (Courtesy of Placentia Public Library.)

Old buildings took on new and sometimes ironic changes of occupants, as this 1947 photograph shows. The town's only theater dated from its earliest years and was long known as the Valencia Theatre. Before World War II, Mexican attendees were asked to sit in the balcony. But by this time, it was showing Spanish-language films, presumably to an entirely Hispanic audience. This building burned down in 1956. (Courtesy of Placentia Public Library.)

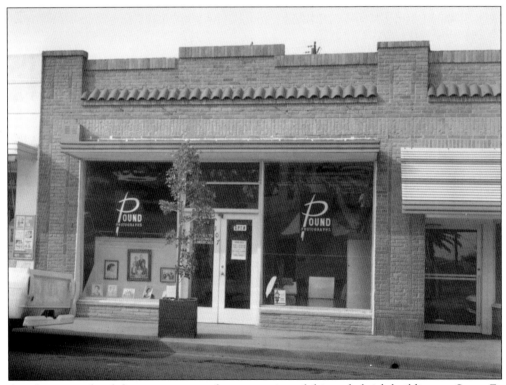

Another example of changing use was the occupation of this early brick building on Santa Fe Avenue by the city's first professional photographer, Ray Pound, in 1949. He went on to be mayor of Placentia. This building later became a Mexican restaurant. (Courtesy of Ray Pound.)

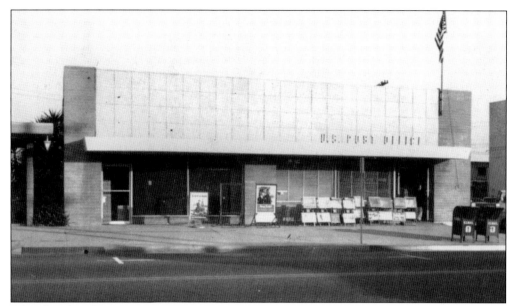

After decades of occupying space in grocery stores and other commercial buildings, with residents sharing mailboxes, Placentia's post office got this sizeable modern facility in 1955. Its location on Bradford Avenue near Santa Fe indicates that the historic downtown was still the center of city activities, even as new construction was beginning to the north. Within 20 years, the post office would move north, and this building would house the American Legion post. (Courtesy of Placentia Public Library.)

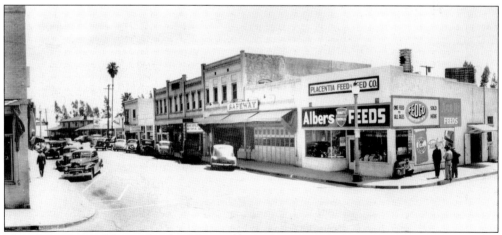

This 1947 picture of the south side of the 100 block of Santa Fe reflects the growing predominance of non-wooden construction—common along much of the business district. It also illustrates two poles of the area economy in the feed store for its historic agriculture next to a small unit of a chain supermarket store for its residential population. (Courtesy of Placentia Public Library.)

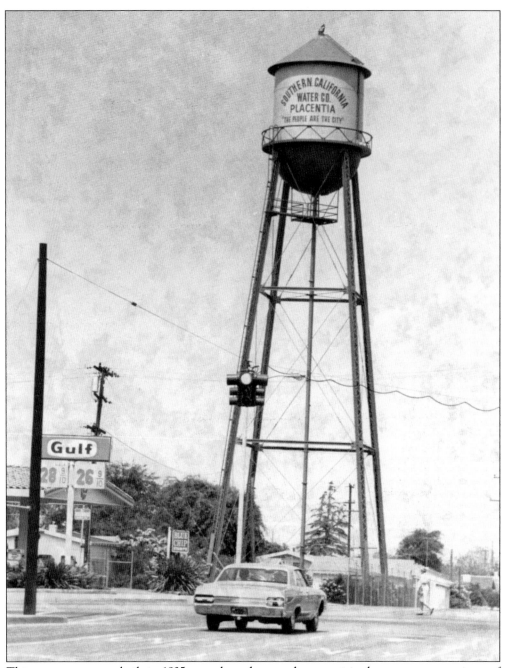

This water tower was built in 1935 to replace the two shorter original towers as a repository of domestic water. It continued in active use until 1993, and it still stands along Chapman Avenue in the old downtown area. It is the city's most distinctive landmark and has been legally recognized as such. In the 1970s, it was repainted to advertise Placentia's status as an All-America City. (Courtesy of Placentia Public Library.)

# *Six*

# COMMUNITY LEADERS
# AND GOVERNMENT

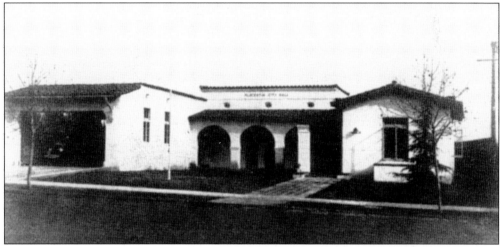

Public buildings not only accommodate the functions of government for many cities; they also serve as symbols of the community. By this standard, Placentia was long lacking. It was not until 1940, or 14 years after the city's incorporation, that it built its first city hall, seen in this 1950s photograph. Prior to 1940, the city's few agencies, including its board of trustees (soon renamed city council), had met in the second floor of the Placentia Bank Building, while the modest amount of equipment the city owned was housed elsewhere. Some early community needs, such as street paving, were handled by the chamber of commerce. Others were funded and run by special districts, including street lighting and the library. This city hall housed all activities of the city's government, including police and fire departments, building planning and permits, and social and community programs. Like several other city halls built at this time in north Orange County, it was largely funded by the federal government through the Works Progress Administration (WPA). This structure served as the home of city government until 1974. In recent years, it has been leased by the city to various nongovernment organizations. Its Spanish Revival style and its historic significance have made it a designated city landmark. As Placentia's government continued to have limited functions into the 1950s, operating mostly with volunteer personnel, this city hall symbolized the modest role that local government played in the overall history of Placentia until recent decades. (Courtesy of Placentia Public Library.)

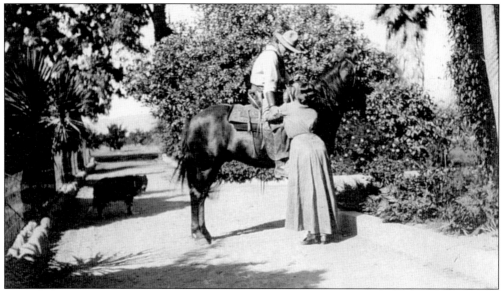

The Bradfords remained a leading family in Placentia after the passing of Albert in 1933. His sons, A. Hartwell (seen here) and Warren, established Bradford Brothers packinghouse in 1922. Warren was active on the school board and the chamber of commerce, while Hartwell engaged in mining, oil, and citrus enterprises. Like many ranchers, he continued to use horses for personal transportation around his lands. (Courtesy of Placentia Public Library.)

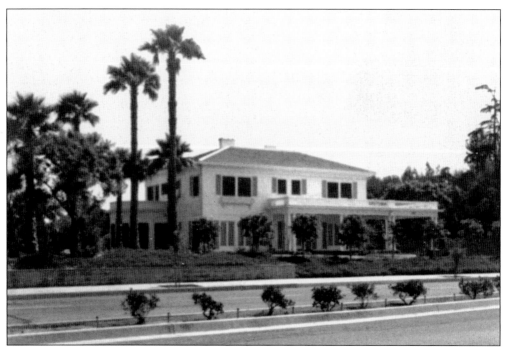

The second generation of leading families often acquired new houses. The junior Charles Wagner built this striking white Colonial Revival house in 1920. This style and the sunroom on the side were unusual features for a ranch home. Used partly as a business site, this house still stands on Yorba Linda Boulevard, near that of the third brother, Joseph. (Courtesy of Key Ranch.)

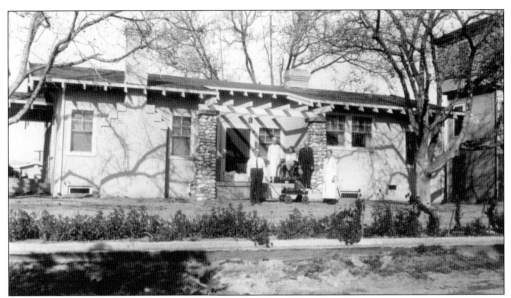

Another influential figure was Harrison H. Hale, seen in this 1926 photograph with his son Roy, brother Will, and their wives. Harrison came to Placentia in 1883 and set up a citrus ranch. He built this house in 1902 and helped secure the railroad right-of-way. He succeeded A. S. Bradford as president of the chamber of commerce, which was established in 1911 and was long a major influence on affairs in Placentia. (Courtesy of Placentia Public Library.)

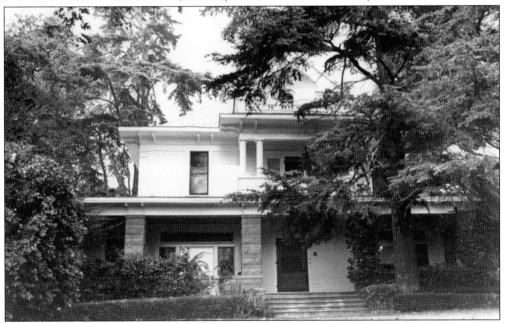

This house was built by George B. Key in 1898 and is shown here after it was remodeled in 1908. He was a founder of Placentia's Presbyterian church and a member of the school board. His son George G. lived in the house until his death in 1989, at which time it was taken over by the county. Encompassing the only remaining orange grove in Placentia and containing extensive collections of photographs and agricultural artifacts, it is preserved as a historic park. (Courtesy of Placentia Public Library.)

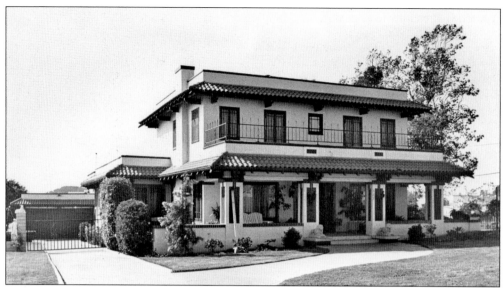

This home of Gilbert Kraemer, son of Samuel, was built in 1920. It is the only remaining house out of several large ones owned by second- and third-generation descendents of Daniel Kraemer. It symbolizes the activities of this family in community affairs in Anaheim as well as in Placentia. This family also remained one of the largest owners of both agricultural and oil lands in the area. This photograph was taken after 1929, when a second story was added. It is a city historic landmark. (Courtesy of Placentia Public Library.)

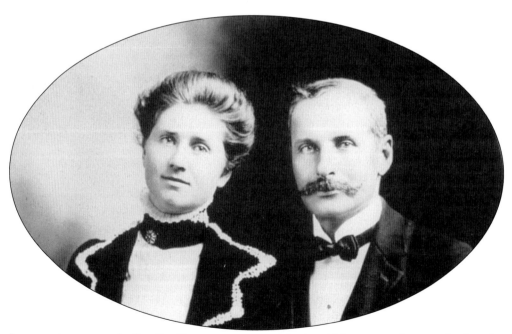

Intermarriage among leading families was common, as this late-19th-century photograph of Attilio and Jane Strain Pierotti shows. She was the daughter of a pioneer rancher. He came in 1876, acquired a ranch, and later served as a director of the Placentia Orange Growers Association. Both were prominent in early community cultural activities. (Courtesy of Key Ranch.)

A second community took shape in the early 20th century among Placentia's growing Latino population. Like the Rodriguez family, shown in this 1916 photograph, many worked on local ranches but lived in the downtown area or, in the case of other families, in the La Jolla area to the south. Some assumed important positions in the community; one member of the Rodriguez family became a policeman. (Courtesy of William Zavala.)

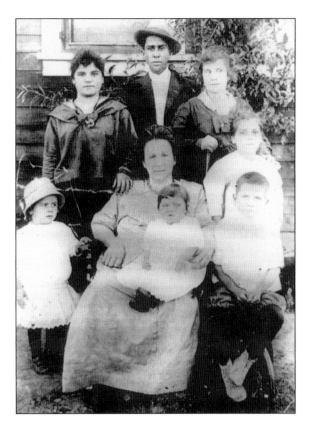

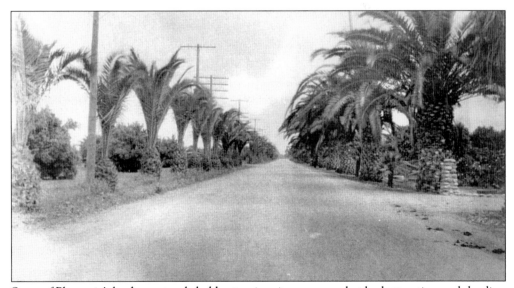

Some of Placentia's leaders not only held extensive citrus acreage but had attractive roads leading to their residences. This picture, taken shortly after World War II, is from the Bradford mansion, looking west along Palm Drive. (Courtesy of Placentia Public Library.)

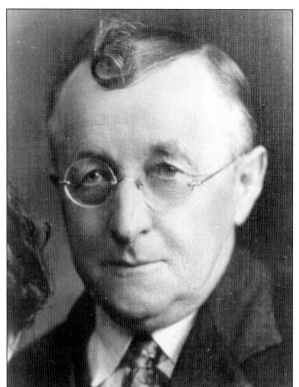

This early-20th-century photograph is of Andrew Ipsen, a Danish immigrant who came to Placentia in 1897. Initially working on Chapman's ranch, he became a partner in one of the city's early grocery stores. He was active in civic affairs, helping organize the petition drive for incorporation and serving on the city's first board of trustees. (Courtesy of the City of Placentia.)

Harrison O. Easton, shown at a typical office desk of the 1920s and 1930s, was Placentia's first mayor, serving from 1926 to 1929. As has remained its policy, the city council selected the mayor from one of its members. From 1919 to 1935, Easton was the manager of the Placentia Mutual Orange Association, and after that, he managed the Placentia Fruit Growers Exchange. (Courtesy of Placentia Public Library.)

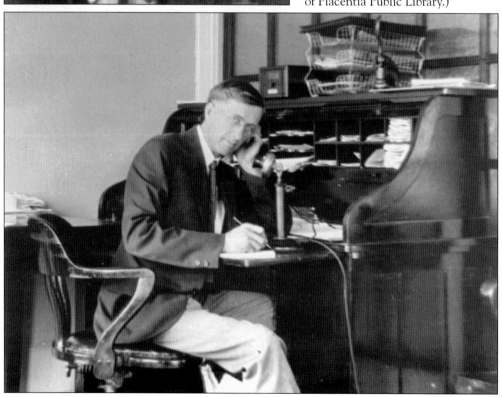

Several Latino residents became leaders of their community after World War II, often being inspired to improve their lot from their military experience. The most prominent of these residents was Alfred Aguirre, seen in this 1943 portrait. He was the first Latino elected to the city council, serving from 1958 to 1962, and was a leader in the movement to end school segregation in Placentia. (Courtesy of Alfred Aguirre.)

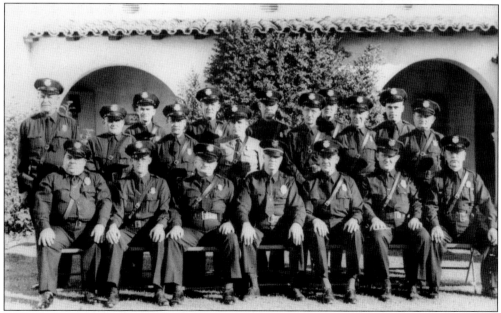

Placentia relied on volunteers for most of its police personnel, and by the 1940s, when this photograph in front of city hall probably was taken, they had grown to a sizeable force. All the people in this picture appear to be white—common among police departments at this time. (Courtesy of John Walcek.)

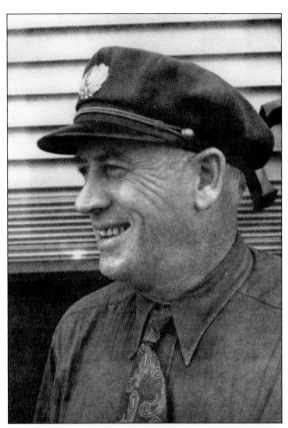

Gus Barnes was the city's second police chief and served from 1929 until his death in the late 1930s. As an example of the multiple duties of the city's few paid staff, Barnes was also in charge of tax collection and road work. (Courtesy of Placentia Public Library.)

This photograph, taken in the late 1930s or 1940s, shows one of the city's few police vehicles and Earl Rhea, one of the city's few paid policemen. Such a limited department reflects the city's frugality in public services and the fact that crime was not a significant problem in these years. (Courtesy of Placentia Public Library.)

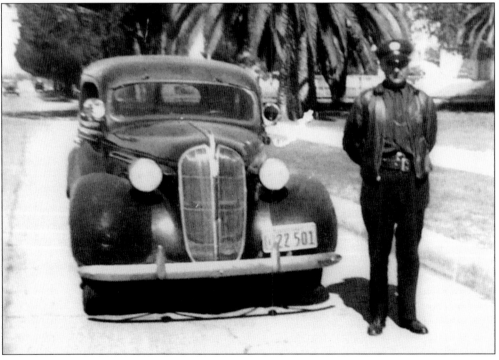

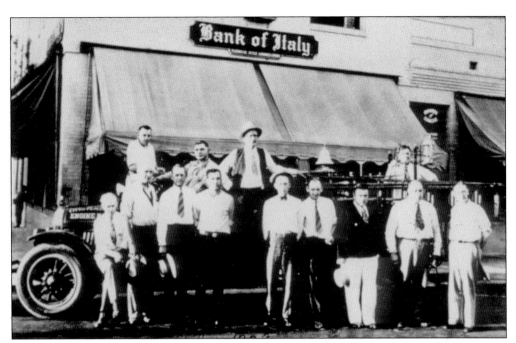

Placentia relied exclusively on volunteers for fire protection until 1957. A volunteer Fire Protection Association was formed in 1912 for the Placentia area, and it became an official department of city government in 1926. The chief and firemen were volunteers. The truck seen in this 1929 picture was purchased in 1927 (consuming most of that year's budget) and was not replaced until 1946. (Courtesy of City of Placentia.)

Placentia established a library district in 1919, but it was a marginal operation for years. The building seen in this post–World War II photograph was the second of several temporary quarters for the library. Most of its books were donated, as its initial budget for buying them was $20. (Courtesy of Placentia Public Library.)

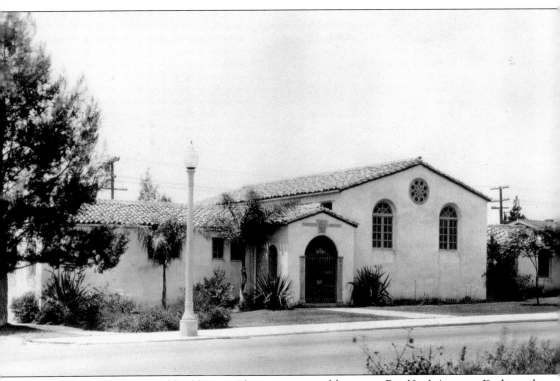

The first publicly owned building in Placentia was its library on Bradford Avenue. Dedicated in 1927, this Spanish Eclectic–style structure was designed by Carleton Winslow, the architect of the Los Angeles Public Library. This building remained the library's site until 1974, when the current library building was constructed. The city acquired the building and subsequently has used it as a senior center. It has been designated as a city historic landmark. (Courtesy of Placentia Public Library.)

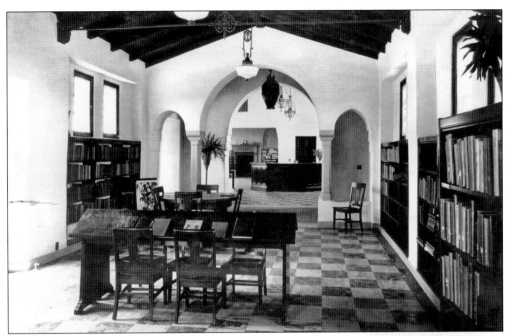

The Spanish style of the library building was attractively carried through to its interior. Thick walls, arches, and columns combined with beamed ceilings, wrought-iron chandeliers, tile floors, and oak woodwork to convey the Mediterranean ambience. Two fireplaces and tiled panels were unusual features for a library. As the Edwin T. Powell Building, these rooms have hosted numerous community events in addition to serving seniors. (Courtesy of Placentia Public Library.)

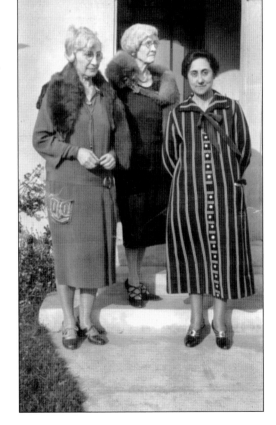

Placentia's library was governed by the Placentia Library District board of trustees. It was unusual among public agencies of its day for being predominantly composed of women, shown in this 1927 photograph in front of the library building. On the right is Lucana McFadden, of the pioneer family, who served on the board from 1922 to 1952. (Courtesy of Placentia Public Library.)

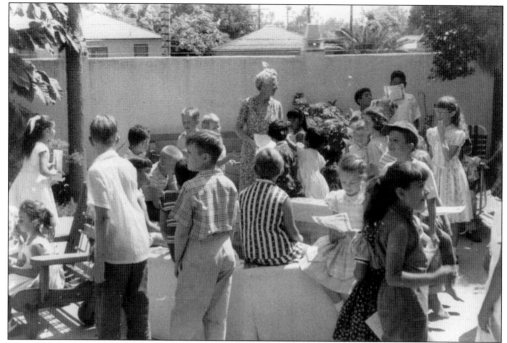

The library offered community programs in addition to its basic functions. One of the most popular was the Summer Reading Program for children, seen being conducted in this 1950s photograph of the library patio. This program has continued to the present. (Courtesy of Placentia Public Library.)

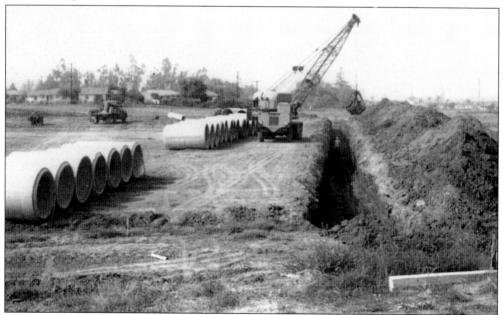

By the 1950s, population growth and the demand for local facilities led the city to expand its planning and public-works activities. A major project of the mid-1950s was the Bargain Basket shopping center, near the site of the first grammar school, where this shot of sewer pipes being laid was taken. (Courtesy of Placentia Public Library.)

# Seven

# AN EMPIRE
# OF ORANGES

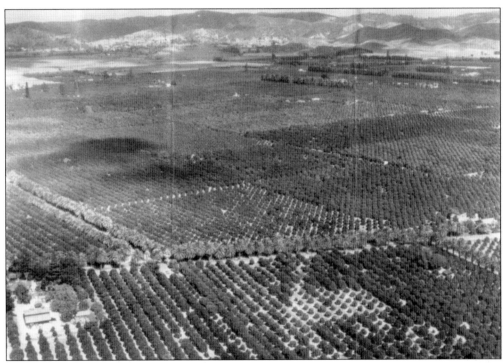

At their peak in the World War II period, citrus groves carpeted most of Placentia, as this photograph of its northern area shows. Ranch residences and barns suggest areas of ownership. Otherwise only occasional rows of palms or eucalyptus break the landscape of Valencia trees. Their crop was the heart of Placentia's economy through the 1950s. Packinghouses were its industrial buildings, and work in them and the groves provided most of the local employment. Orange growers' associations that managed the packing, sale, and shipping of Valencias were among most important local organizations, with leading ranchers on their governing boards. Citrus labels made Placentia known to other regions. From the early 1900s to mid-century, oranges influenced activities in Placentia as extensively as they covered its land. (Courtesy of Placentia Public Library.)

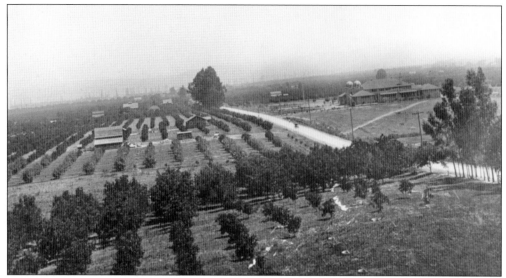

In this picture taken *c.* 1920, when orange trees were younger and smaller, several aspects of the locale outside of the small town can be seen. Bradford Avenue was one of a few substantial-size roads. Barns are the largest buildings outside of the Bradford Elementary School, built in 1912. Oil derricks to the north indicate a new development in the economy, while semi-circular standpipes in the foreground suggest that much of its irrigation system was underground. (Courtesy of Placentia Public Library.)

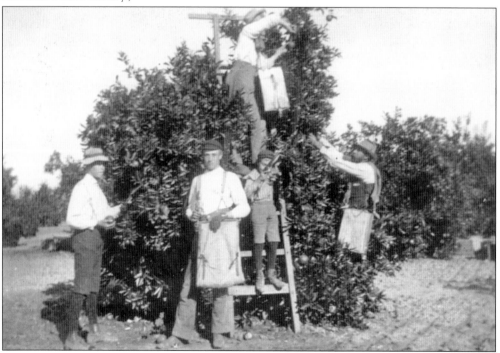

Although outside laborers harvested most oranges, rancher families got into the job, as is seen in this photograph of the Bradfords. A. S. Bradford is on the right, with sons Hartwell in the foreground and young Warren and Percy on the ladder. Higher fruit was reached by wooden ladders resting on tree limbs or a third leg. (Courtesy of Placentia Public Library.)

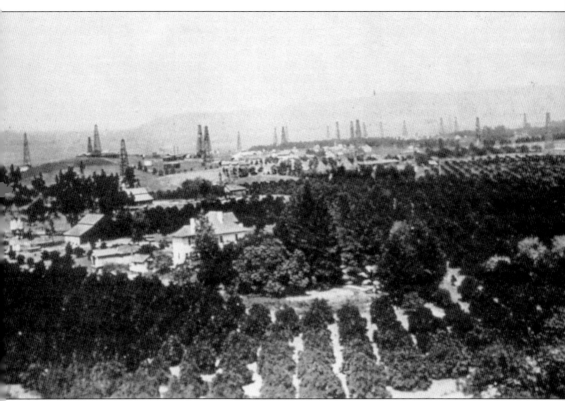

The George B. Key ranch, seen here around 1912–1913, was typical of many in Placentia in size (between 20 and 40 acres) and in having several outbuildings and a barn in addition to a substantial house. The walnut trees in the lower right corner show that oranges had not completely taken over. Oil wells in the hills to the northeast were an early sign of another industry that would be important to Placentia by the 1920s. (Courtesy of Key Ranch.)

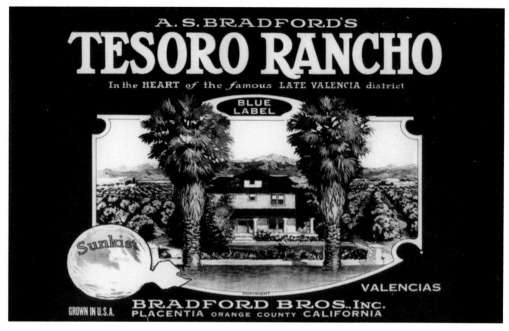

Growing and selling Valencia oranges became an industry by the early 20th century. One aspect of this commercialization was the labels that were put on fruit crates. While some were works of art, their main purposes were to advertise the grower or packer and to designate the quality of fruit, which is why one grower often had several different labels. Some labels portrayed local scenes, as did Bradford's "Tesoro Ranch." Others used biblical or historic images, like the "Queen Esther" brand. Several portrayed the landscape of orange groves, palms, and mountains. (Courtesy of Virginia Carpenter.)

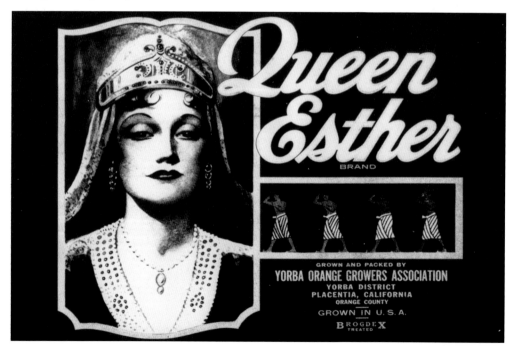

In the 20th century, irrigation changed from open ditches to underground pipes in many groves. A key component was standpipes, usually made of concrete, seen in the foreground of this undated photograph. They were linked to underground concrete pipes that carried water from one standpipe to the next. (Courtesy of Placentia Public Library.)

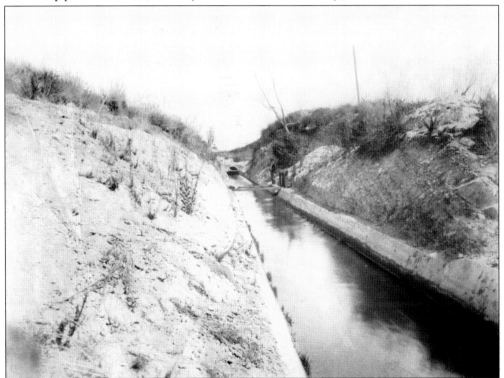

Open canals by the 1920s were also becoming concrete-sided, as this photograph of the Cajon Canal shows. Much of the work of installing these walls and culverts (seen in background) was done by Latino workers. (Courtesy of Placentia Public Library.)

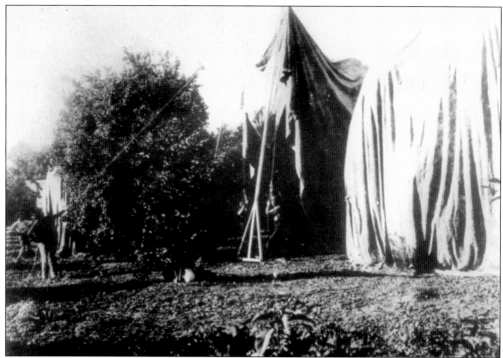

Insects and diseases had been problems for many crops, and oranges were no exception. The earliest widely used technique for controlling these was fumigation, seen being conducted in this photograph. Canvas was draped over a tree, forming a tent. A worker placed a jar of water and acid in this tent and dropped cyanide into it. Gas quickly formed, killing any non-plant life—including the worker, if he did not leave the tent quickly. Several prominent Placentia ranchers nearly lost their lives in this occupation. (Courtesy of Key Ranch.)

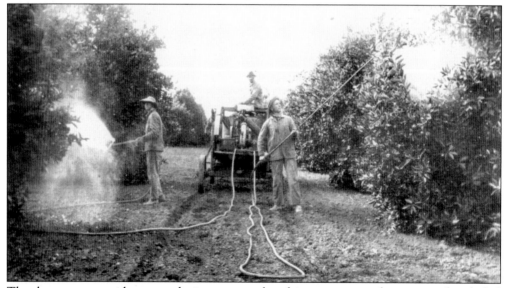

The dangerous cyanide-tent technique was replaced in some groves by spraying less lethal insecticides. This early-20th-century photograph shows the protective clothing used in such spraying and the mules that dragged the tanks of poison through the groves. (Courtesy of Key Ranch.)

Several alternatives to poisons were eventually developed for controlling insects. This 1960 photograph shows one, which was using a vacuum to suction bugs from trees. Another, developed in 1921 by Claude Russell, was to raise ladybug beetles to control mealy bugs. Ladybugs were also used to combat the scale disease. (Courtesy of California State University, Fullerton.)

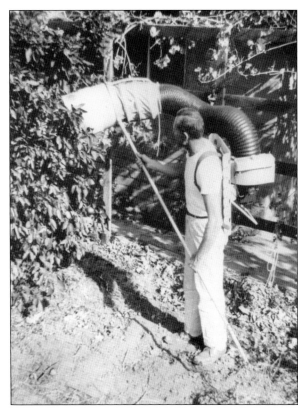

Packinghouses remained the center of shipping oranges through the 1950s. Most resembled this 1911 Placentia Orange Growers Association (POGA) building. Partly wood, partly brick, it had doors for packing trucks, seen in this photograph, and separate ones on the track side (not visible) for loading box cars. After the 1933 earthquake, this structure was replaced by one made of concrete and gunite. (Courtesy of Fullerton Public Library.)

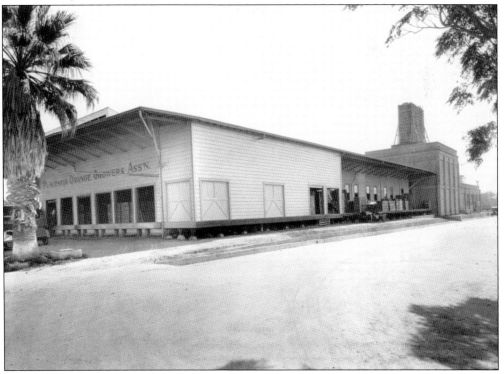

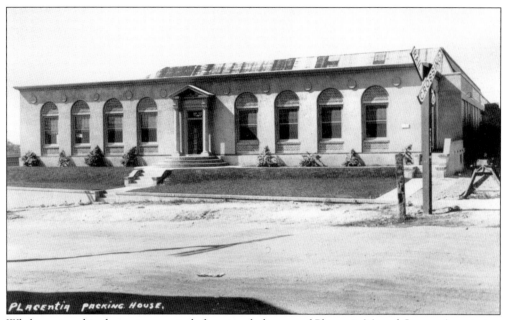

PLACENTIA PACKING HOUSE.

While most packinghouses were strictly functional, the second Placentia Mutual Orange Association (PMOA) structure had a striking facade. Built in 1920, it featured elaborate designs on its columns and windows. This building still stands, though it is no longer used for citrus packing. (Courtesy of Placentia Public Library.)

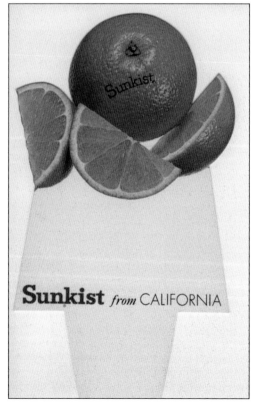

Sunkist *from* CALIFORNIA

Cooperative marketing of oranges began on a national scale with formation of the California Fruit Growers Exchange (CFGE). In 1907, it adopted the trademark "Sunkist," which was stamped on tissues that were wrapped around each orange and on tabs, such as this one, put on boxes during packing. Several Placentia associations and packinghouses were affiliated with CFGE. (Courtesy of Placentia Public Library.)

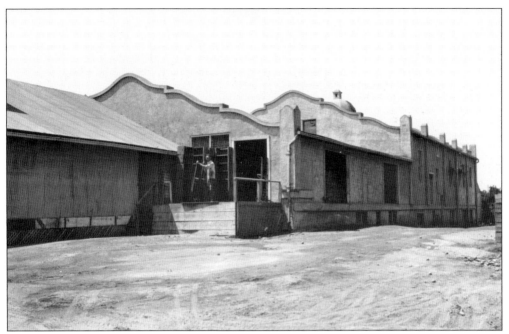

Some packinghouses were owned and run by individual ranchers, like those of the Bradford Brothers and of C. C. Chapman. The Chapman Building, seen in this photograph, was one of the more architecturally distinctive structures in Placentia, featuring a mission motif, which is also seen on one of his crate labels. (Courtesy of Fullerton Public Library.)

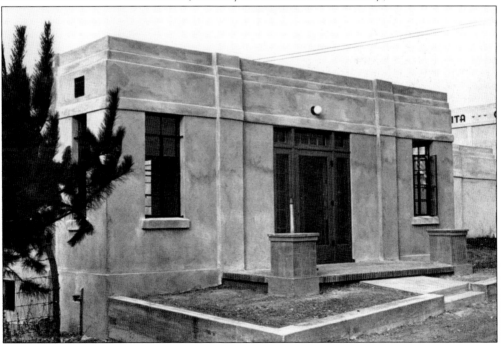

More reflective of the architecture of its day was this 1930s building used by the POGA as an office. The reconstructed packinghouse adjacent to it used the same motif. Both are still standing but no longer used for citrus. (Courtesy of Placentia Public Library.)

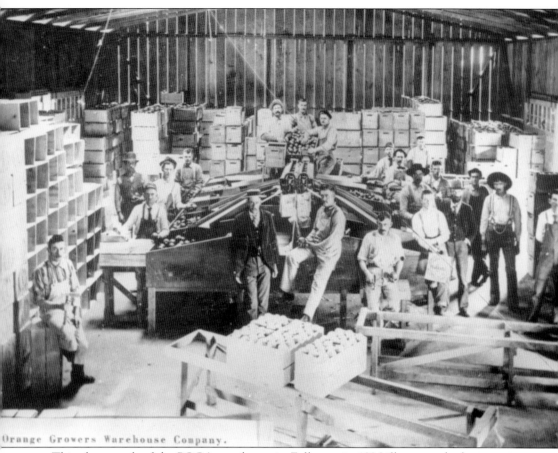

Orange Growers Warehouse Company.

This photograph of the POGA warehouse in Fullerton in 1896 illustrates the basic equipment used in sorting and packing oranges at that time. Field boxes (rear wall) were dumped and sent into several bins by chutes, which could be a way of separating the fruit by size. Workers neatly packed them into lighter, cleaner boxes (foreground) for shipping. Often each orange was wrapped in tissue (though here they seem to be separated in layers by dark paper). At this time, nearly all packers were men, mostly white. (Courtesy of First American Title Company.)

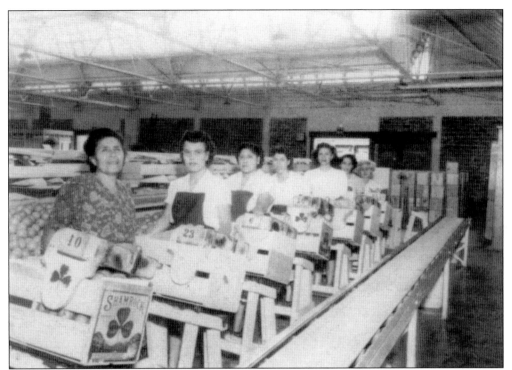

By the 1940s, women were the predominant labor force in Placentia packinghouses. This 1940s photograph of the PMOA also illustrates the ethnic transition from using whites, who composed most of the earliest female packinghouse workers, to employing Latinas. Such jobs did not necessarily connote status, as the second person on the left, Julia Aguirre, was the wife of a future community leader and councilman. (Courtesy of Fred Aguirre.)

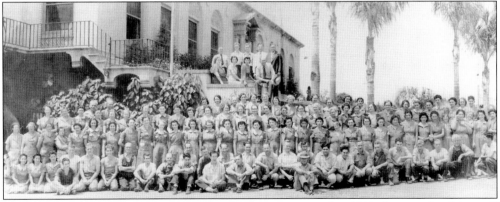

The number of people employed in packinghouses is seen in this 1941 photograph of the staff of one facility—PMOA. This period was the peak of citrus production in Orange County. Most of the men were employed in loading boxes, with women making up nearly all the packers. (Courtesy of Mary Castner.)

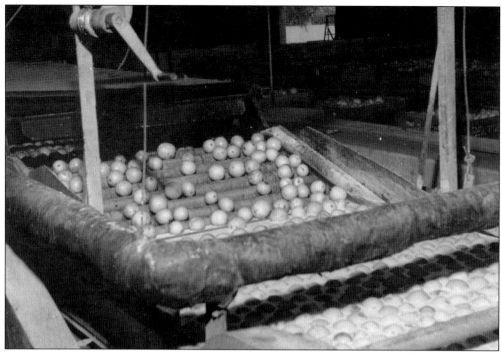

Whether removing cyanide or soot from smudge pots or giving fruit a shine, washing oranges was an important part of the packing process. In early periods, each orange was scrubbed by hand with a brush. By the time of this photograph, probably taken in the 1950s, mechanical cleaners performed this task much more efficiently. (Courtesy of Placentia Public Library.)

By the late 1940s, some other aspects of the packing process, such as attaching lids onto boxes, had become mechanized. As this photograph suggests, this led to considerable reduction in the number of workers needed. (Courtesy of Placentia Public Library.)

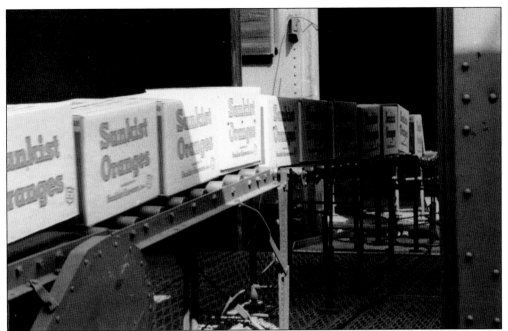

This stream of boxes reflects the increasing volume of oranges shipped from Placentia by the third and fourth decade of the 20th century. In 1945, California produced 36 million boxes of Valencias, a majority of them from the Placentia-Fullerton area. Cardboard boxes such as the ones in this photograph replaced wooden ones about this time. (Courtesy of Placentia Public Library.)

Some Placentia ranchers influenced citrus growing far beyond their community. This postwar photograph is of the citrus committee of the American Farm Bureau Federation, a major national farmers' association. Second from the right is local rancher Jack Christensen. Other Placentia residents made significant contributions to insect control. (Courtesy of California State University, Fullerton.)

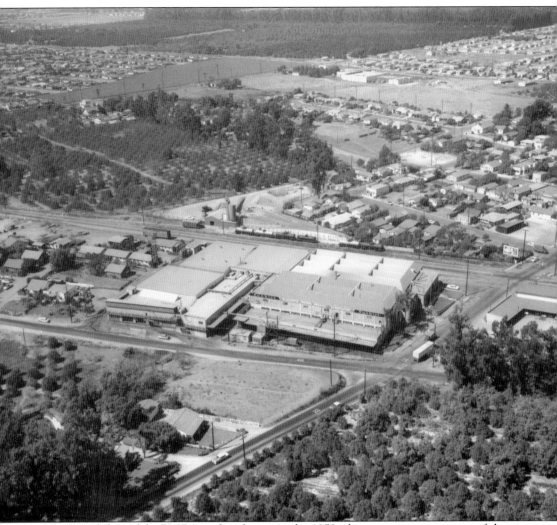

This aerial shot of the PMOA packinghouse in the 1950s shows many components of the citrus industry. The warehouse had been doubled in size in the 1930s to better accommodate both truck and rail transit. Most workers lived in the town of Placentia, seen across the tracks, or to the south in the La Jolla area. But some lived in the barracks to the left of the packinghouse. Citrus groves had been planted up to the edges of the town. This vibrant scene belies the fact that, in less than a decade, Valencia oranges would be an industry in decline. And the dynamics of life in Placentia would be moving away from this downtown area. (Courtesy of Ray Pound.)

*Eight*

# THE OIL ERA

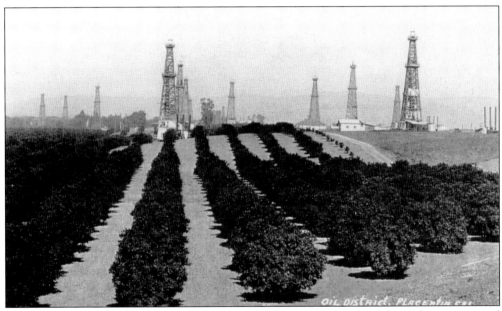

Placentia's economy became more than farming in the second decade of the 20th century, as oil production came on the scene. Oil drilling started in the hills to the north in Brea and spread to adjacent parts of Placentia soon after 1910 and then to eastern areas by 1920. There whole fields were opened in the tiny town of Richfield (later Atwood) and neighboring areas, which became collectively known as the Oil District. This 1920s photograph shows that part of this region already had citrus groves and that oil wells were drilled adjacent to and sometimes within them. Also visible are the housing and the processing and equipment buildings that accompanied derricks to compose a new landscape for parts of Placentia. As oil extraction increased, it joined orange growing and ranching as a mainstay economy, becoming a distinctive part of the city's history. (Courtesy of Anaheim Public Library.)

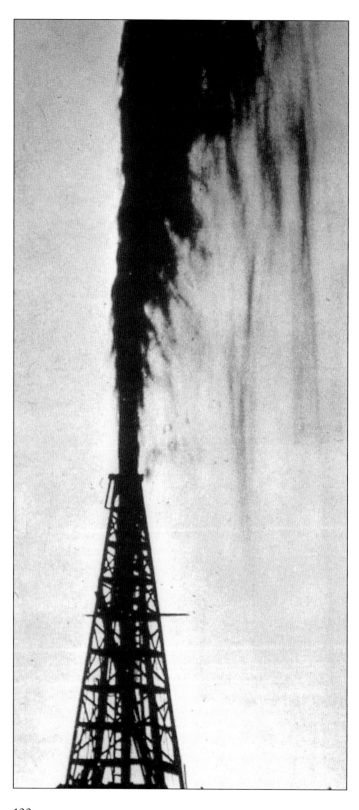

Extensive oil production in Placentia began dramatically in March 1919, when Chapman Well No. 1 struck oil. C. C. Chapman had leased land to the east of downtown to Union Oil Company, which had drilled unsuccessfully for nearly two years before this strike. The resultant gusher, seen in this photograph, lasted for days and attracted large crowds. This well would produce 200 million barrels in its first five years, which prompted rapid development of other fields in the area. (Courtesy of Placentia Public Library.)

Gushers were the result of cable-tool drilling, which penetrated a pool of oil and gas with no soil above the bit. The resultant emission of gas and oil was wasteful and at times ruined acres of orange groves. This photograph, taken on the Kraemer lease land *c.* 1920, is of one of several gushers on that property alone. It also shows the extensive pipes needed to convey oil and the unkempt conditions in many oil fields. (Courtesy of Anaheim Public Library.)

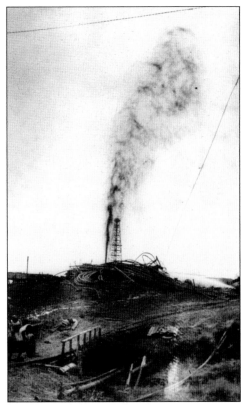

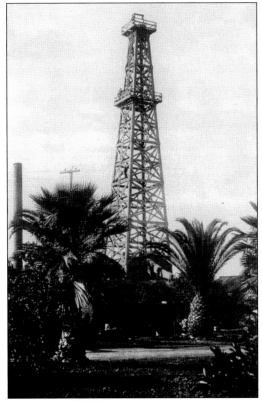

Oil derricks were usually made of wood in this period. They were essential to drilling and hence would be built wherever there was expectation of finding oil. This photograph of the Bradford estate shows that derricks often went up right by the driveway or yard of a rancher's residence. (Courtesy of Placentia Public Library.)

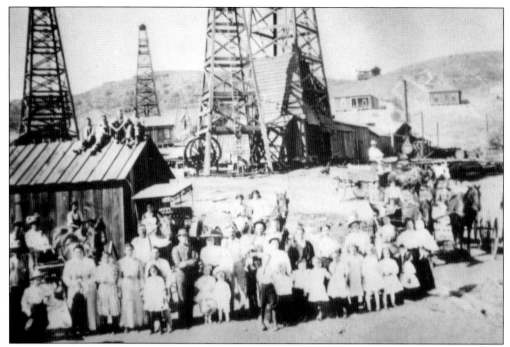

This c. 1900 photograph of an early oil field in Olinda, north of Placentia, shows the proximity of derricks, equipment facilities, and housing. Unlike most farm laborers, oil workers usually lived near the wells. Early wooden derricks were shorter than later ones and used large bull wheels to raise the bits for dropping. The number of women and children is unusual, as oil camps generally housed single male workers. (Courtesy of Placentia Public Library.)

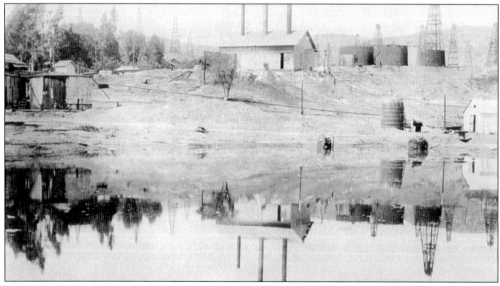

This early oil field in northern Placentia shows the wooden tanks that stored oil as it was pumped up. It was then piped to railroad tank cars along a special track from the main Santa Fe line to Olinda. It was such a tank car breaking loose that caused the 1916 wreck. The engine plant in the center was essential for building derricks and tanks as well as for making and maintaining drilling tools. (Courtesy of Placentia Public Library.)

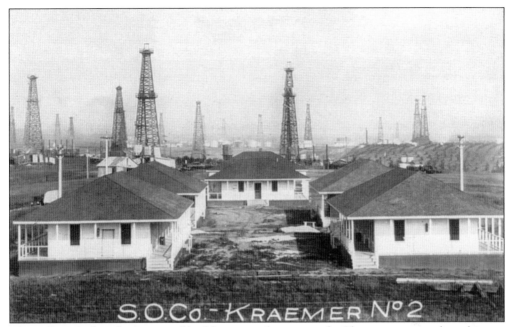

The influx of oil workers required building several camps in the Placentia area, such as this one on the land leased by Sam Kraemer. The oil company usually built and rented the housing. Oil workers often worked 12 hours a day, seven days a week, under hazardous conditions. These camps were often abandoned when the companies ceased to drill or maintain many wells. (Courtesy of Placentia Public Library.)

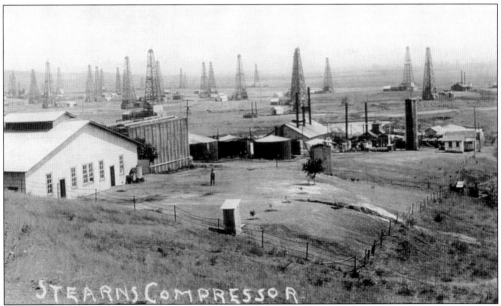

Oil was Placentia's first nonagricultural industry, and it brought large machinery, trucks, and industrial buildings into the area. This 1920s shot of a field in northwest Placentia features a compressor used to process natural oil and steam plants, which produced noise and smoke. The small building in the foreground was probably an outhouse, as oil fields often lacked indoor plumbing. (Courtesy of First American Title Company.)

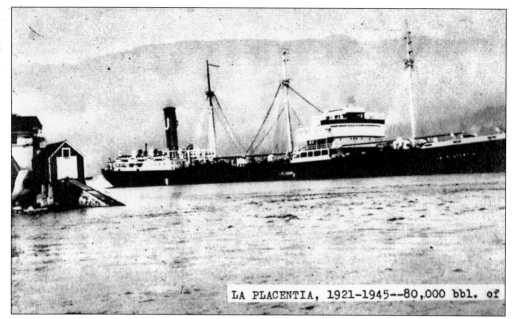

LA PLACENTIA, 1921-1945--80,000 bbl. of

Placentia's importance in Southern California's oil boom was demonstrated when Union Oil Company named one of its three tanker ships *La Placentia*. Seen in this photograph, it was built in 1921 and had a capacity of 80,000 barrels. It operated through World War II, after which it was scrapped. (Courtesy of Placentia Public Library.)

The 1920s oil boom coincided with increasing harvests of oranges. This combination brought such wealth to Placentia that someone coined the phrase seen on this tire cover. Much of this wealth went to a few ranchers who also owned oil-bearing lands, which they leased to drilling companies. But the town generally profited from the increased trade the workers brought, while farmers enjoyed lower prices from the water companies that owned oil lands. (Courtesy of John Walcek.)

By creating an abundant supply of gasoline, the oil boom contributed to a rapid change in transportation. By 1920, Placentia had many commercial and passenger vehicles, such as the ones in this lot. Trucks, such as this bread van, also facilitated the delivery of processed foods and their replacement of locally grown produce. (Courtesy of Placentia Public Library.)

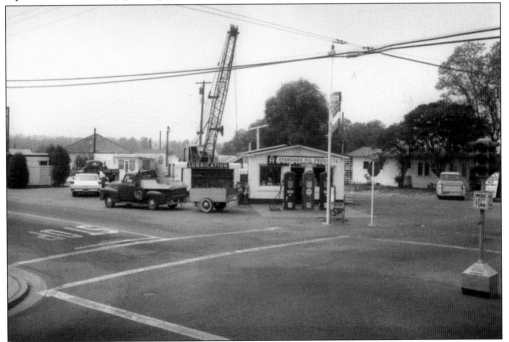

Paved streets, traffic signals, and service stations followed the growing use of cars all over Southern California, including Placentia. This photograph was taken in the 1950s, but the service station dates at least to the early 1920s, when it was a Union Oil station. This is also the first stop sign in the town. (Courtesy of Placentia Public Library.)

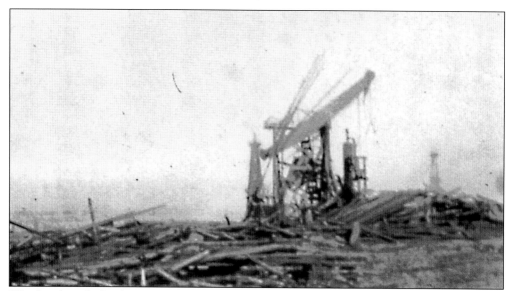

Wooden derricks by the 1920s were usually 100 feet tall and were vulnerable to fire and wind. Santa Ana winds that seasonally swept through the Placentia area could reach sufficient force to cause the damage seen in this 1933 photograph. Such destruction contributed to the replacement of wooden derricks by steel ones before World War II. (Courtesy of Key Ranch.)

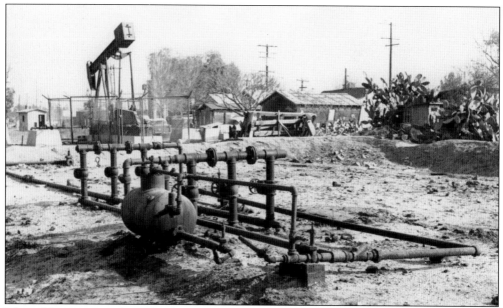

The oil boom petered out by the 1930s, due partly to the Great Depression and partly to overproduction. This shot of Atwood in the late 1950s or 1960s shows how a landscape of oil derricks had changed to a few isolated pumps, while dwellings in what may have been an oil camp had deteriorated into shacks that were largely inhabited by Latino workers. (Courtesy of Placentia Public Library.)

# *Nine*

# SCHOOLS AND CHURCHES

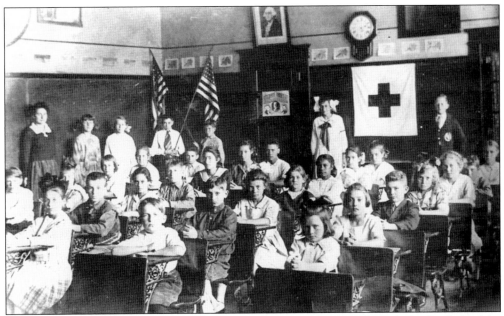

Schools remained the most important public institution in Placentia through the first half of the 20th century. This photograph of a class at the Placentia Grammar School was probably taken during World War I. It illustrates the importance of schools in imparting patriotism and respect for order as well as in providing an education. The Red Cross flag also suggests that schools were centers for promoting civic causes. By the second decade of the 20th century, churches became a second important institution in community life, as both Catholic and Protestant denominations built houses of worship. By the end of the 1920s, Placentia had four schools and four churches. Schools especially had separate sites for the town's two populations: Anglo and Hispanic. Not until the 1940s would the segregation of school children in Placentia begin to change. (Courtesy of Key Ranch.)

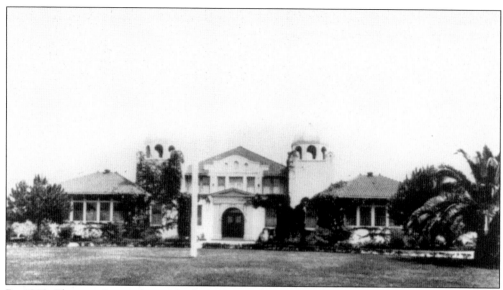

By 1912, Placentia's population had outgrown the grammar school on Placentia Avenue, so this eight-room school was built on Bradford Avenue. It offered classes through the eighth grade. Fullerton remained the closest high school until 1933, when this building also housed the first high school classes in Placentia. Part of this building burned in 1934, but one structure remains on the Valencia High School campus as a city historic landmark. (Courtesy of Placentia Public Library.)

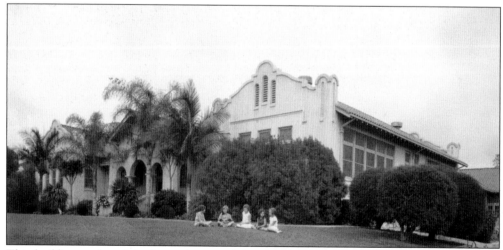

This building replaced the burned parts of the grammar school in 1936. By this time, other elementary schools had predominantly or exclusively Latino enrollments, so Bradford Avenue became the school most whites attended. This building was phased out as an elementary school by the 1960s and became part of Valencia High School. (Courtesy of Placentia Public Library.)

This photograph of a Bradford Avenue School kindergarten class in 1935–1936, composed mostly of white students at a time when school-age Hipanics outnumbered whites, illustrates the city's policy of separating students by ethnicity. It also shows that, in the years between the fire that destroyed part of the original school and its replacement, education continued in Placentia. (Courtesy of Placentia Public Library.)

Placentia's population growth in the first two decades of the 20th century required new schools. One was on Baker Street in the downtown area. This photograph of an all-Mexican class there illustrates the segregation policy of placing most Latino students in these newly created schools. This was based on the assumption that they learned more slowly and differently than white students and needed greater immersion in English. (Courtesy of Alfred Aguirre.)

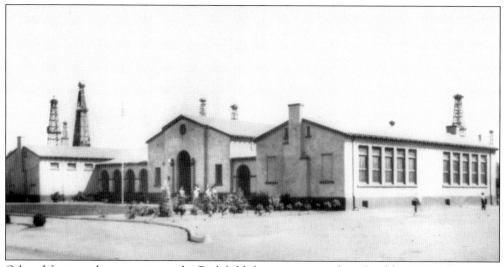

Oil and farm workers coming to the Richfield district requested a school by 1914. Like several later ones, this second school in Placentia began as a bungalow and later acquired the building seen here. By 1930, it became a predominantly Latino school. Concern about its security in earthquakes led to students leaving it for La Jolla in 1940. The building housed *bracero* farm workers during and after World War II and was later used for food storage. (Courtesy of Placentia Public Library.)

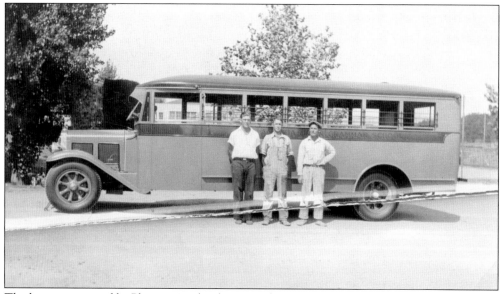

The large area served by Placentia's schools required transportation for students. This late-1920s or early-1930s photograph shows one of four buses the elementary school district acquired. This was thanks to Placentia being one of the richest districts in the state. These buses also expedited the sending of Latino students to separate schools. (Courtesy of Placentia Public Library.)

Placentia established a high school district in 1933. Valencia High School was built next to Bradford Avenue School. The first buildings constructed were the two main ones, shown in this photograph, and they opened in 1935. Others were built in the late 1930s, some with assistance from federal programs like the WPA. Although the high school district covered the same area as the elementary one, few Mexican students attended the high school until after World War II. (Courtesy of Placentia Public Library.)

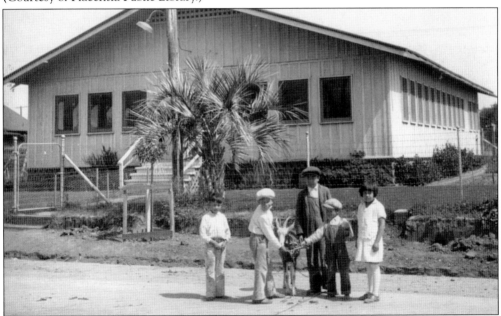

In 1932–1933, the Baker Street School, which had been damaged in the 1933 earthquake, was replaced by this Chapman Hill School a few blocks away. The site had been used as a center for Americanization classes, suggesting that some of the growth in Placentia's Mexican population came from immigrants. This school was almost entirely Latino in its enrollment until it closed in 1950. (Courtesy of Placentia Public Library.)

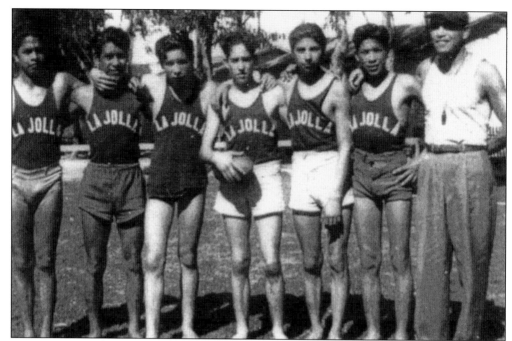

While athletics teams came early to some Placentia schools, Mexican schools did not have an organized physical-education program until 1939, when Gualberto "Burt" Valadez (left) came to the La Jolla School. One of his early teams was the La Jolla "Red Devils," who gave themselves that name when they were sent bright red uniforms. By the 1940s, teams such as this one, including a girl's softball team, had the equipment and training to enter interschool competition. Valadez later taught at Valencia High, retiring in 1983. (Courtesy of Alfred Aguirre.)

La Jolla School was established in the 1920s for the growing colony south of Placentia. As other Latino schools were closed, La Jolla enrolled most of their students. Its brick schoolhouse of six classrooms was a haven for victims of the 1938 flood. The gym, shown in this photograph, was built in the 1940s, and it is the only surviving structure. It has been recognized as a city historic landmark. (Courtesy of Placentia Public Library.)

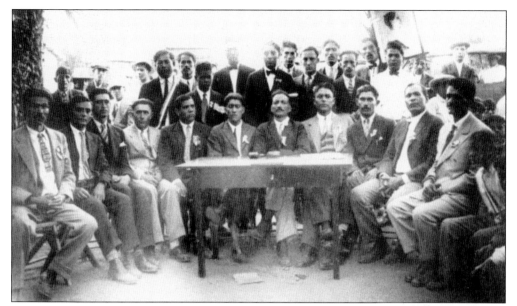

Many Mexican Americans who served in World War II returned with a desire to change their inferior, segregated schools. The priest at St. Joseph's helped them form the Veterans and Citizens of Placentia, seen in this photograph, in 1946. By 1948, their protests and other legal cases led the Placentia school board to begin transferring Latino students from Chapman Hill to Bradford Avenue, thus ending its formal policy of segregation. However, La Jolla remained a de facto Latino school for years after. (Courtesy of Alfred Aguirre.)

Placentia school athletics teams included the elementary level, as this photograph from the late 1940s or early 1950s shows. The coach on the left in John Tynes, who came to Placentia in 1944 as a physical-education teacher and who served the city past the end of the 20th century as physical-education coordinator, school-district superintendent, city-council member, and mayor. (Courtesy of California State University, Fullerton.)

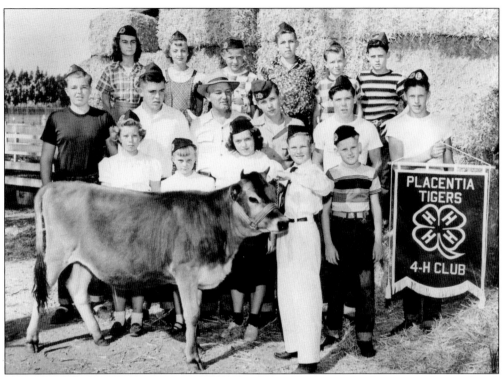

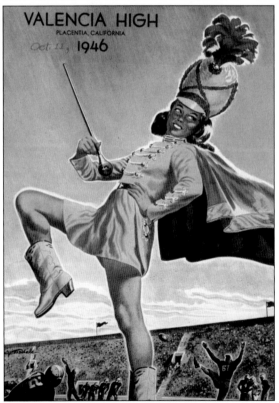

Placentia schools promoted agricultural education through the 1950s. This photograph of a 4-H Club shows such activities at the elementary school. Valencia High School had a large Future Farmers of America club. (Courtesy of Mary Castner.)

By the end of the 1930s, varsity sports were an important part of Valencia High School and the Placentia community. Football was especially popular, as is illustrated by this 1946 cover of the program the school printed for each of its home games. The school held an annual football banquet, which drew some of the largest audiences of any community event. (Courtesy of Placentia Public Library.)

The Valencia High School also served as a community facility. Extensive fields to the north provided space for various sports and recreational events. Part of the campus also served as a park, featuring the picnic benches used by these women in this 1940s picture. (Courtesy of Placentia Public Library.)

In 1911, the recently established Church of the Nazarene set up a congregation in Placentia led by the pioneer Wright family. They built the second church in town and located it on several sites until this building was erected in 1964. It is still in use as a church. (Courtesy of Placentia Public Library.)

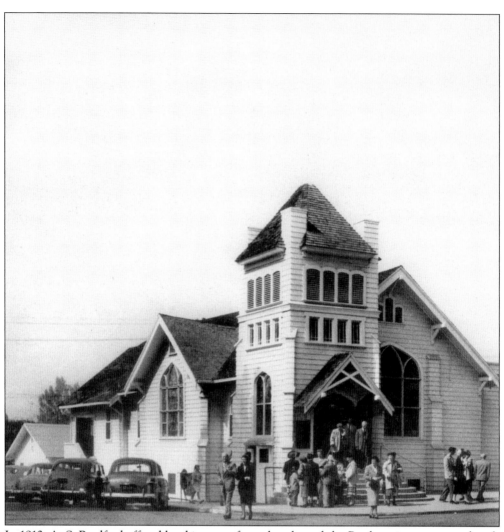

In 1912, A. S. Bradford offered land in town for a church, and the Presbyterians set up a church organization and raised funds to build on it. Placentia's first church building was constructed out of boards hauled from the old Placentia Grammar School when it was torn down. They also acquired the 1884 school bell. The church was opened in 1913 and changed little through the late 1940s, when this photograph was taken. The Presbyterians moved out in the 1950s, but this building, which is now covered with stucco, continues to be used as a Spanish Nazarene church. (Courtesy of Placentia Presbyterian Church.)

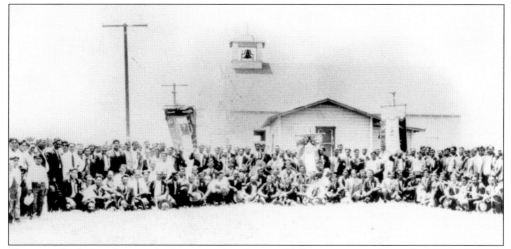

Placentia Catholics for years had to go to Anaheim or Fullerton to attend parish churches. In the 1920s, two missions from the Anaheim and Fullerton churches were set up in or near Placentia. One was La Virgen de Guadalupe Church in La Jolla. As this gathering shows, this modest wooden building could attract a large crowd (the event is unknown), and it served a mix of Anglo and Hispanic parishioners. (Courtesy of California State University, Fullerton.)

A Catholic church was set up in downtown Placentia in 1926, when Sam Kraemer donated a lot to it. Known as St. Joseph's, it was a mission first of the Anaheim and later the Fullerton parish until 1948, when it became a parish in its own right. The church was built in a wooden bungalow style and included a parish house. In 1953, St. Joseph's moved to a new, larger building with a school on Bradford Avenue. (Courtesy of Placentia Public Library.)

The Calvary Church, seen in this photograph, began when Charles Fuller, a local rancher, started a Bible class at the Presbyterian church. It grew in numbers and independent ideas until 1925, when Fuller established Calvary Church. This building was erected in 1926, and it was from here that Fuller began broadcasting his sermons over the new medium of radio. He soon after moved to Long Beach, and his program evolved into the Old Fashioned Revival Hour. Fuller also founded Fuller Theological Seminary. The Calvary Church still occupies this building. (Courtesy of Placentia Public Library.)

# *Ten*

# COMMUNITY LIFE

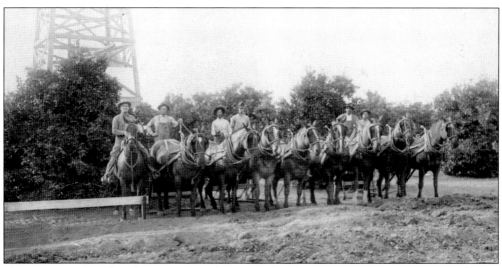

Placentia's ranchers found recreation in their agricultural environment in several ways. One was riding horses and appearing in riding exhibitions and contests. The El Rodeo Riding Club, seen in this photograph probably taken in the 1920s, was the main horseman's organization in the town. A leader of this club was John Wagner Jr., the community's most renowned rider. He was the son of a pioneer settler and owned a large ranch in Placentia. The background of citrus groves and an oil derrick illustrates the main sources of the riders' wealth. Those less affluent often turned to sports for recreation or joined one of a growing number of social and cultural clubs. Many of these activities were undertaken in different groups, on different occasions, and at different sites by the city's two ethnic communities. (Courtesy of Placentia Public Library.)

## PLACENTIA BOOSTER SONG

Tune—"My Bonnie Lies Over the Ocean"

*Words by Estella H. Walker*

Placentia lies close to the railroad,
Placentia lies near to the sea.
To find for her golden valencias
A market, a sure way there'll be.

*Chorus:*
Boost for. Boost for.
Bost for Placentia, we love her the best.
Boost for. Boost for.
Our rich little town of the West.

Sunshine reigns supreme in Placentia,
So pleasant we care not to roam.
The people so kind and so earnest
They're just l.ke the old folks at home.

*Chorus*

With oranges, walnuts and oil wells
The source of its riches untold,
It offers investor and worker
A chance honest plans to unfold.

*Chorus*

Probably written in the 1920s, this clever song reflects the optimistic spirit of the small town amidst boom years for oil and oranges. The lyrics seem primarily an expression of local pride, but they also fit in with the extensive literature used throughout Southern California to attract new settlers. (Courtesy of Placentia Public Library.)

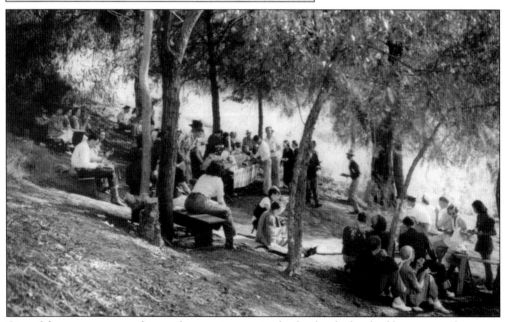

One of the most common forms of recreation was in the few lands that had been set aside among the groves for public use. Gilman Park, seen in this photograph from the 1940s, was on the Bowen Ranch on the northwestern edge of Placentia and was a favorite site for group picnics. The park is still in use. (Courtesy of Placentia Public Library.)

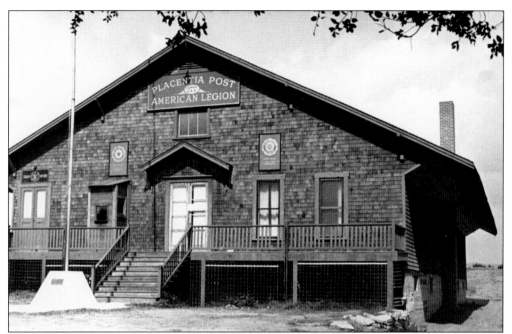

One structure used for recreation in early Placentia was the American Legion Post Building. Originally constructed as a packinghouse for the Placentia Cooperative Association, it was given to the American Legion when it established a post in Placentia in 1928 and was moved to Chapman Avenue. It was used through the 1950s for dances that sometimes featured big bands. The building was torn down in the 1960s, to be replaced by a monument to veterans. (Courtesy of Placentia Public Library.)

The Round Table Club also sponsored social events, such as this barn dance in 1950 at its clubhouse. Its Las Brindadoras club put on monthly programs ranging from speakers on "the frontiers of the 50s" to entertainment. These local events drew large attendance partly because, aside from Knott's Berry Farm, neighboring cities, such as Anaheim, had not yet established centers of mass entertainment. (Courtesy of Placentia Public Library.)

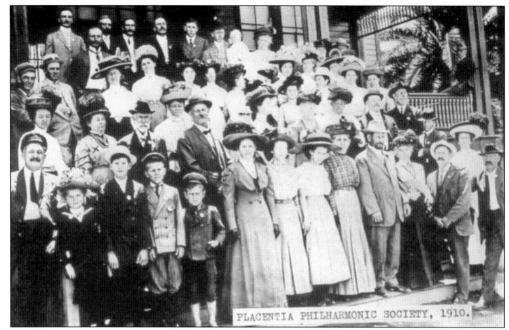

PLACENTIA PHILHARMONIC SOCIETY, 1910.

Other cultural groups included the Placentia Philharmonic Society, which was set up in 1900. One of its activities was in 1910, when it took this group of about 50 on the Balloon Route Trolley trip along Pacific Electric tracks west to beaches. The organization continued through about 1920, then seems to have passed from public view. (Courtesy of Placentia Public Library.)

The Mexican community had its own cultural celebrations. The most prominent from the 1920s to the 1940s was La Fiesta de Las Patrias, which celebrated Mexican Independence Day each September 16. It included floats, guest speakers, street dances, and, as this photograph of the 1927 event shows, an annual queen and her court. This event was held at other Mexican communities besides Placentia until they were consolidated into one county-wide affair in 1940. (Courtesy of Alfred Aguirre.)

The Mexican Independence Day celebration covered two days and required months of planning. Placentia's event in 1927 drew this large crowd, mostly of Mexican ancestry. Many came from Atwood, La Jolla, and other *colonias*. The event celebrated Mexican heritage in various ways, one being the sashes carrying the stripes and colors of Mexico's flag. (Courtesy of Alfred Aguirre.)

One of the few sources of recreation in the La Jolla area was this handball court. Built in 1928 as a wooden structure, it was reconstructed in 1930 with brick. It is believed to be the first such court in Orange County, and Latinos from other towns came here to engage in individual or team competition. It was torn down in the 1950s. (Courtesy of Eduardo Castro.)

Fine-arts exhibits were held in Placentia by the post–World War II years. This photograph is of one in the 1950s at the Bagnall Ranch, whose large, tastefully furnished rooms were the site of numerous social gatherings. (Courtesy of Placentia Public Library.)

Though Placentia did not have the massive wartime influx that Los Angeles had, those who moved to the town found housing scarce. The school district alleviated the problem somewhat by converting vacant school buildings into apartments. This provided relief to those such as John Tynes, seen in this photograph, who brought their family's basic furnishings with them. (Courtesy of Placentia Public Library.)

Victory Corps

Placentia joined communities throughout the nation in supporting World War II. Students and staff at Valencia High School formed a Victory Corps, which organized work on victory gardens, bond sales, and a Junior Red Cross. Their logo from the 1943 edition of their yearbook, *Tesoro*, shows some symbols of the war effort, while the collage of photographs shows various wartime groups and activities in Placentia. (Courtesy of Valencia High School.)

The Santa Ana River was subject to periodic flooding, with serious ones coming in 1900, 1916, and 1927. The most memorable flood was the result of a massive rainfall throughout the Los Angeles Basin on March 3, 1938, which claimed about 100 lives and created many scenes like the one in this picture from the Atwood or La Jolla area. (Courtesy of Key Ranch.)

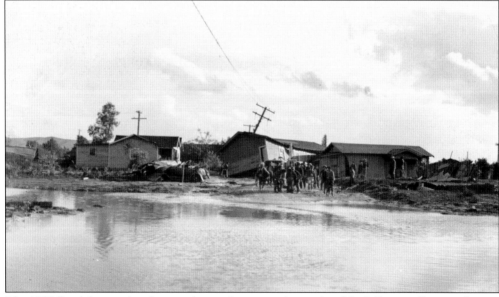

The 1938 flood damaged or destroyed many houses in Atwood and La Jolla, as well as in adjacent parts of Anaheim. This photograph captures just a portion of the residences that were affected. Houses left standing often had most of their furniture swept out by the raging waters. (Courtesy of Placentia Public Library.)

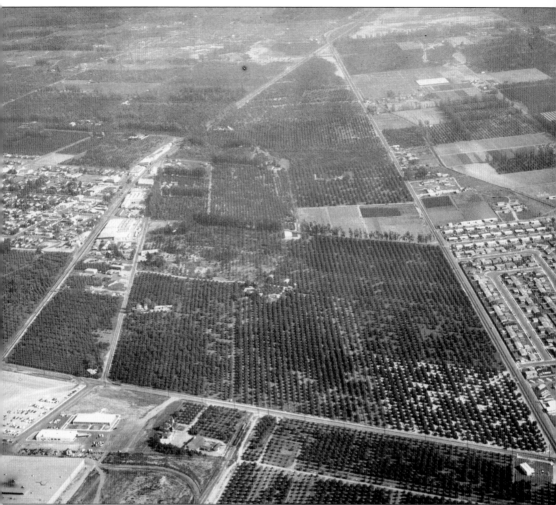

In many ways, Placentia had changed little between 1910 and the late 1950s, when this aerial was taken. It was still a small town surrounded by miles of citrus groves. A row of packinghouses provided the only significant industry. Ranchers' houses, such as the Crowther estate in the foreground, remained its most notable residences. Streets were now paved, but traffic on them was minimal. Yet this picture also suggests that this scene would soon change. Cleared fields in the foreground were being taken over by a complex of commercial buildings. Thinning groves in the center may have been due to the "quick decline" disease, which would contribute to the demise of orange growing in many parts of the Southland. And the stretch of La Jolla at the left is indicative of the wave of housing development that would soon change this small town into a suburban city. (Courtesy of Ray Pound.)

# ACROSS AMERICA, PEOPLE ARE DISCOVERING SOMETHING WONDERFUL. *THEIR HERITAGE.*

Arcadia Publishing is the leading local history publisher in the United States. With more than 3,000 titles in print and hundreds of new titles released every year, Arcadia has extensive specialized experience chronicling the history of communities and celebrating America's hidden stories, bringing to life the people, places, and events from the past. To discover the history of other communities across the nation, please visit:

## www.arcadiapublishing.com

Customized search tools allow you to find regional history books about the town where you grew up, the cities where your friends and family live, the town where your parents met, or even that retirement spot you've been dreaming about.